SMALL DOG BIG

BARBARA KARANT

FOREWORD BY **ALEXANDRA HOROWITZ**

GALLERY BOOKS

New York | London | Toronto | Sydney

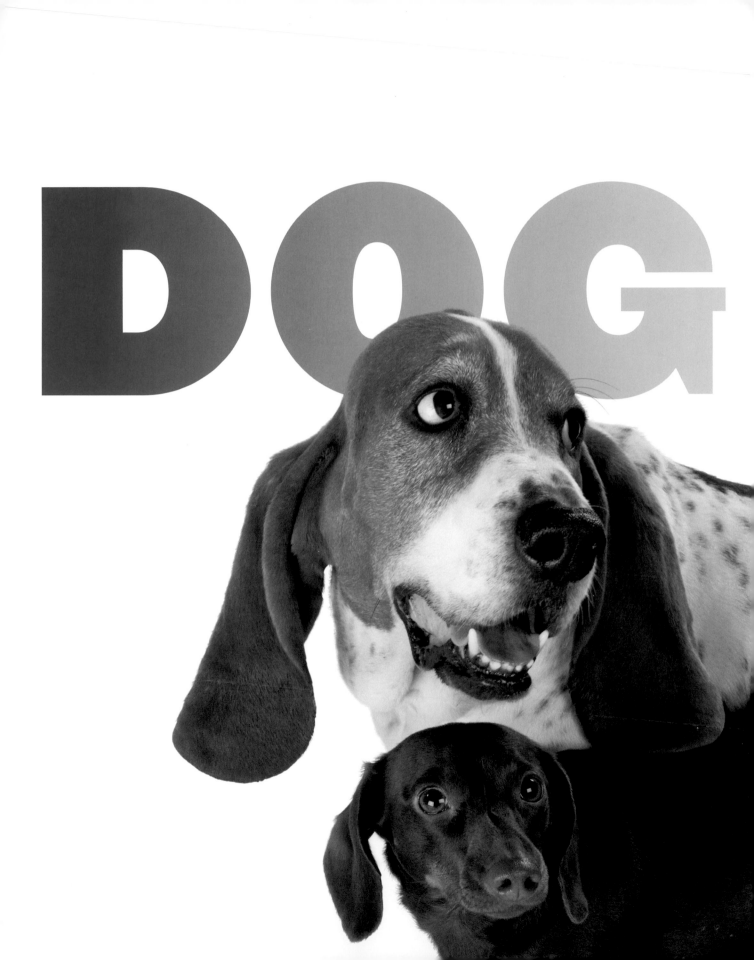

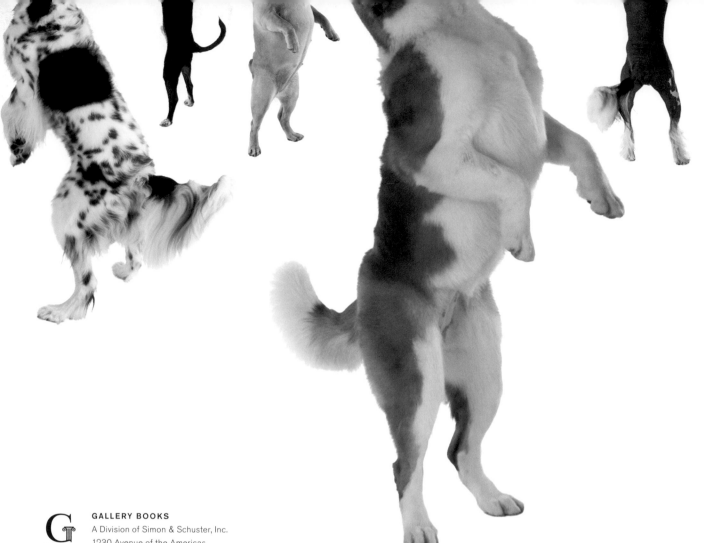

GALLERY BOOKS

A Division of Simon & Schuster, Inc.
1230 Avenue of the Americas
New York, NY 10020

Copyright © 2010 by Verve Editions
Foreword © 2009 Alexandra Horowitz

*All rights reserved, including the right
to reproduce this book or portions thereof
in any form whatsoever. For information
address Gallery Books Subsidiary Rights
Department, 1230 Avenue of the Americas,
New York, NY 10020.*

First Gallery Books hardcover edition
April 2010

Gallery Books and colophon are
trademarks of Simon & Schuster, Inc.

*For information about special
discounts for bulk purchases, please
contact Simon & Schuster Special
Sales at 1.866.506.1949 or
business@simonandschuster.com.*

Designed by The Grillo Group

Manufactured in China

smalldogbigdogthebook.com

Karant, Barbara
Small dog, big dog / Barbara Karant.
p. cm.
1. Dogs—Size. 2. Dogs—Size—Pictorial
works. I. Title.
SF426.K37 2010
636.7—dc22
2009033047

ISBN 978-1-4391-5745-9

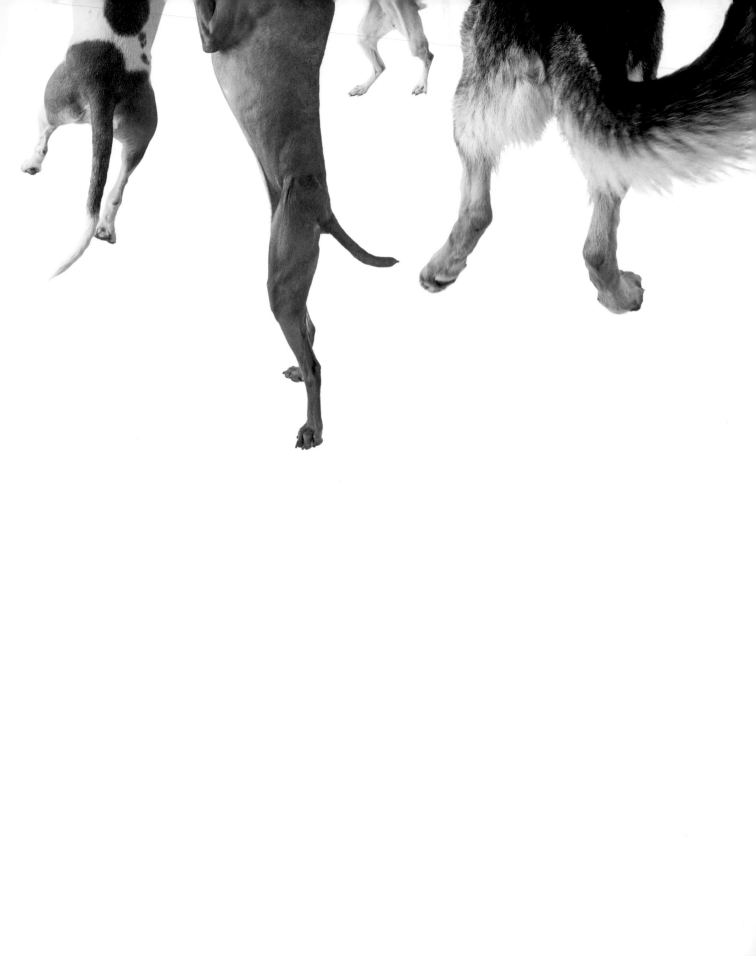

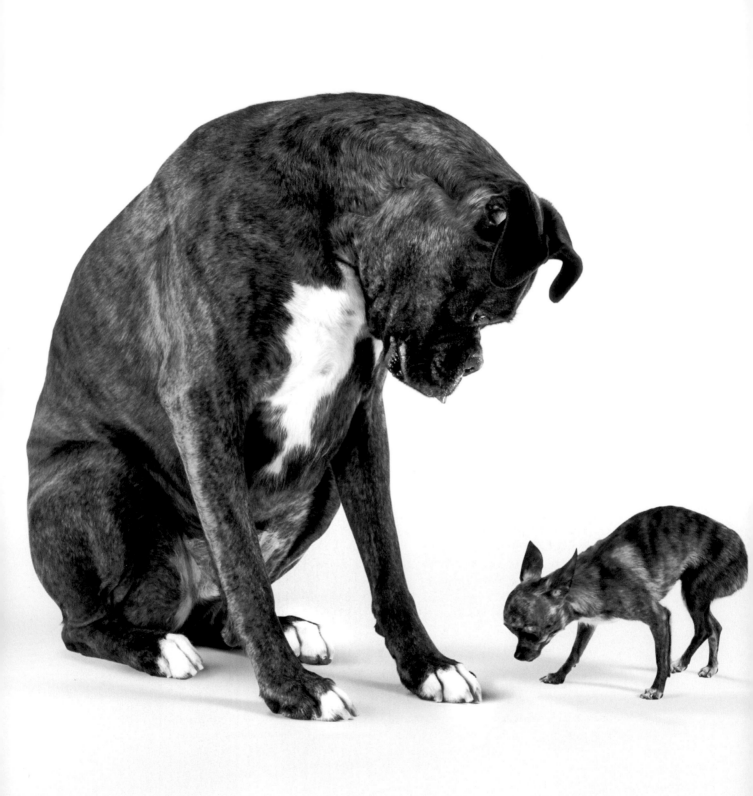

FOREWORD

ALEXANDRA HOROWITZ

IN ONE OF HIS ESSAYS, the Argentinean writer Jorge Luis Borges alludes to a delightful (and presumably mythical) "Chinese encyclopedia," which has a curious manner of classifying animals. Not for this tome the dry classification scheme based on biological similarity. Instead, all animals, from fleas to elephants, are organized into one of twelve groups, according to what must have been more useful characterizations for the time. One class of animals is those "belonging to the emperor"; another is the "tame"; still another, "fabulous." Dogs might have fit under any of those headings, as well as some of the others: "stray dogs," "frenzied," or, knowing puppies, "having just broken the water pitcher."

These days, dogs are familiarly lumped into more straightforward categories: breeds. There is nary an owner who does not know, or will not make a playful guess at, the breed or breed-hodgepodge of the dog of the house. Ultimately, though, the naming of the breed of a dog does not satisfy our need to describe them, to classify these lovely creatures into groups based not just on their genetic history, but also on their behavior, their personality, and their physical bearing.

In fact dog owners and admirers seem already to heed an unspoken taxonomy of types of dogs very much in the spirit of the Chinese encyclopedia. People speak of "ball dogs": dogs who do not see anything but the ball-shaped items of the world. There are "people dogs": those who seem to prefer the company of us humans to that of other dogs. Everyone knows "dogs who will not stop barking"; "dogs you want to touch"; "playful dogs"; "dogs who like to be chased." There are "sad dogs," "nosy dogs," and "droolers." In our memories exist "childhood dogs," "strange dogs," and the longed-for "dogs in the window." Requiring their own category, perhaps, are "poodles."

And of course there are, as Barbara Karant demonstrates in these exquisitely rendered photographs, "big dogs" and "small dogs": those remarkable examples of this remarkable species, whose members have a greater variety in size than any other animal.

We may believe that a little dog "thinks she's big" (and thus boldly walks up to the nose of a giant dog), or a big dog "thinks he's small" (and thus tries to squirm onto your lap), but dogs act as though they know their size. It simply doesn't matter to their dogness. A big dog will sniff a little dog with just as much interest as he will a dog his own size; a small dog will play-bow onto the snout of a giant. The tail of a Great Dane may be the same length as an entire Pekingese, but the wag of the tail means the same thing for each. Their ears flatten, drop, or perk at the same sights and sounds; a Yorkie's miniature raised hackles bears the same message as those of a mastiff.

Dogs are terrific observers of us—of our habits, peccadillos, and manners. In these images Karant lets us loiter a while observing them in return. By the final page, they transcend their categories, and are less "big" or "small" than simply doggish. It is due to the power of the photographs that we are able to see that which dogs have always seen, but which we have forgotten.

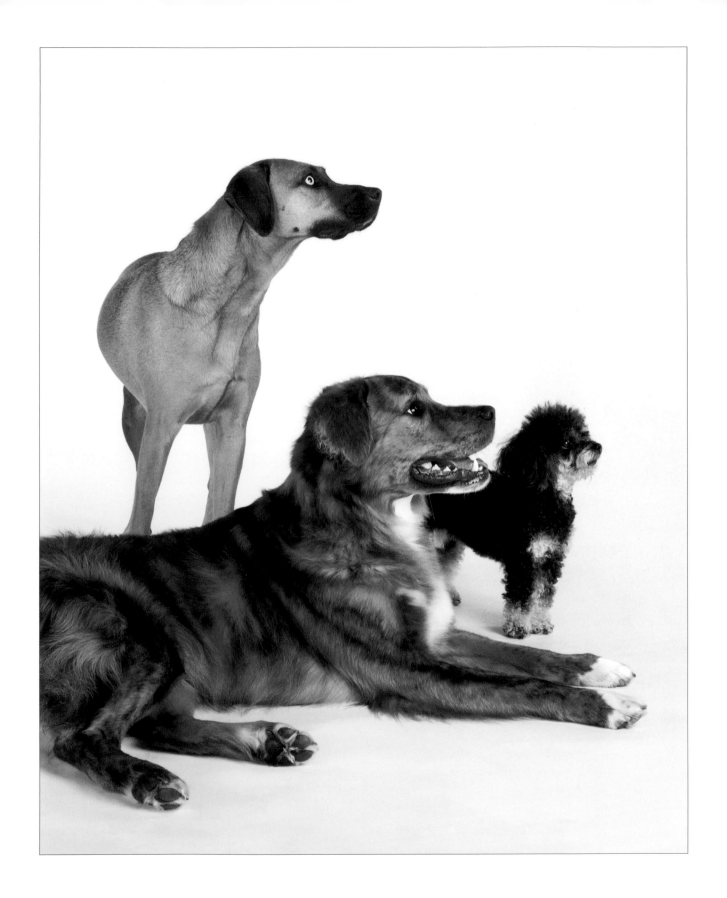

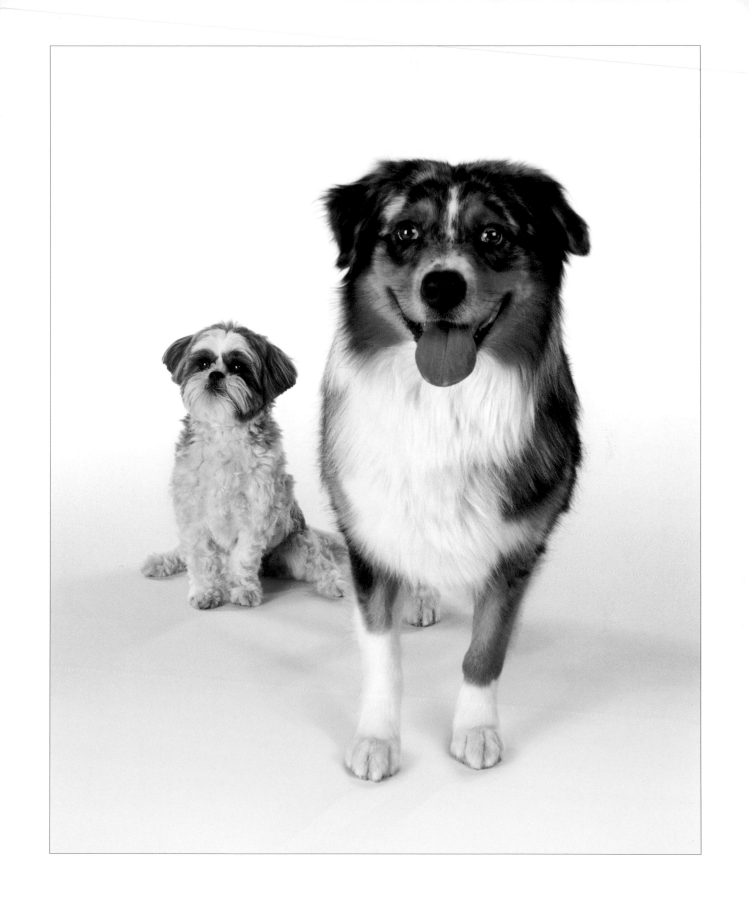

THERE IS AN ADVANTAGE TO SIZE. IT GETS YOU NOTICED.

BETHANY MCLEAN

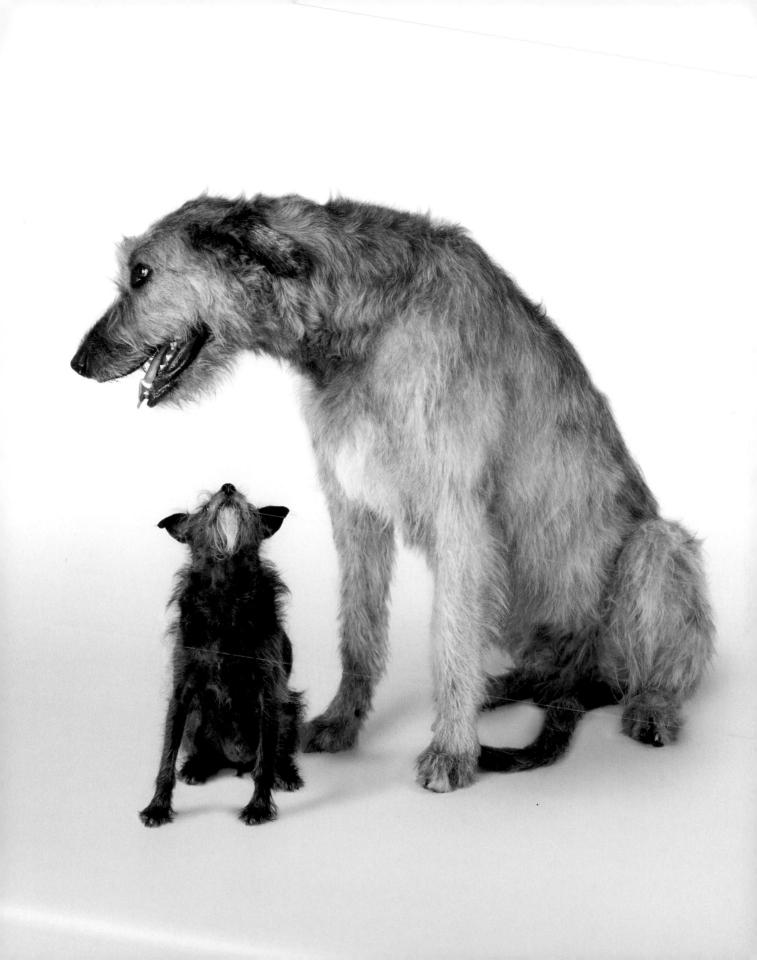

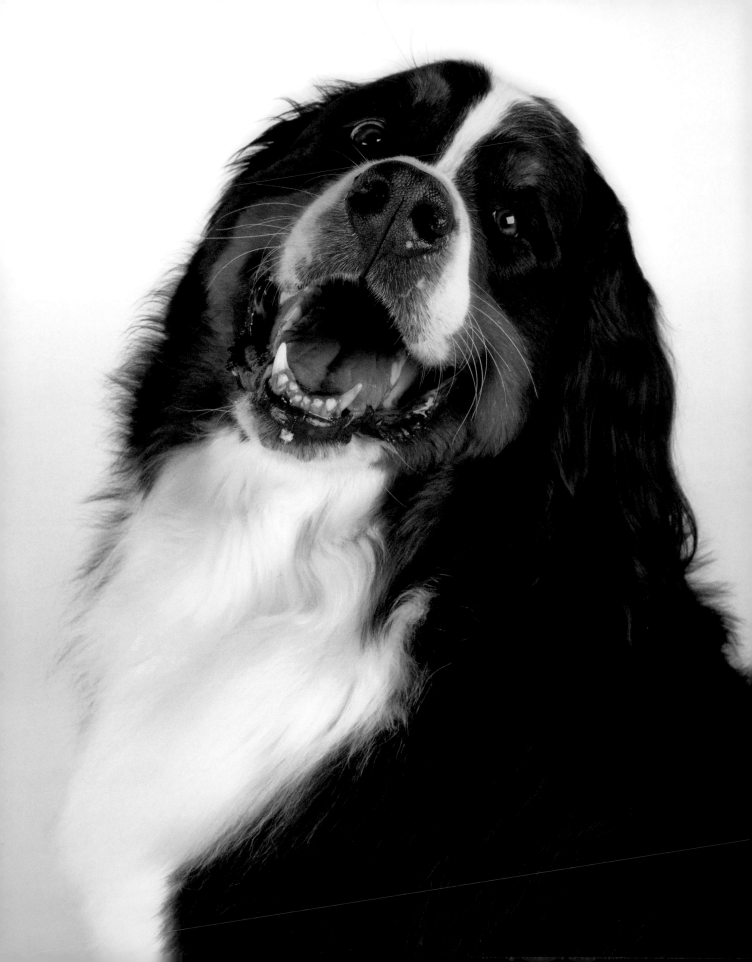

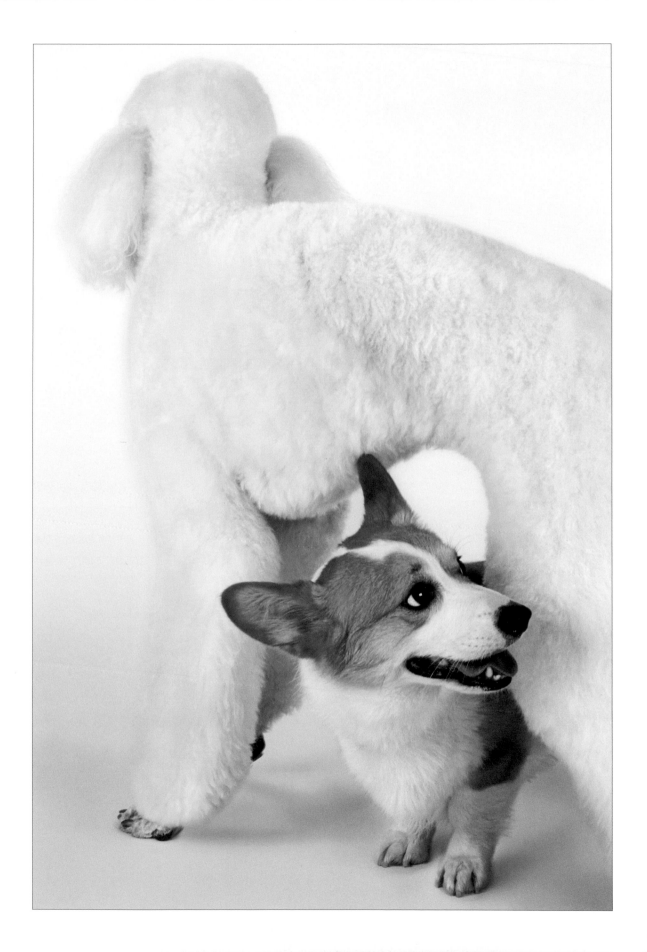

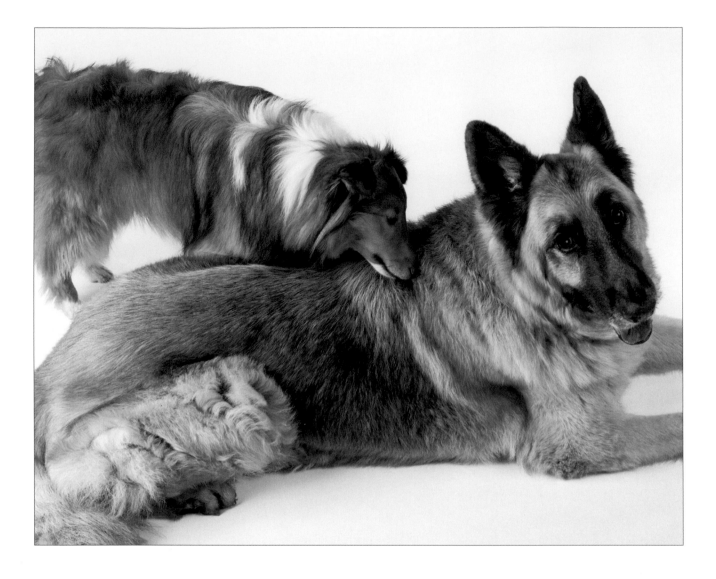

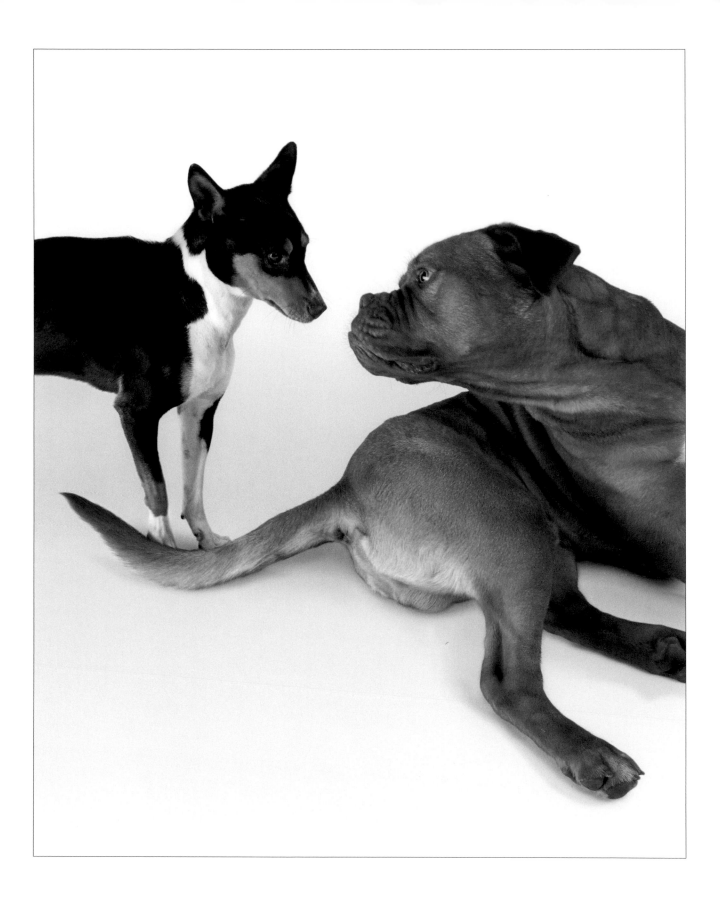

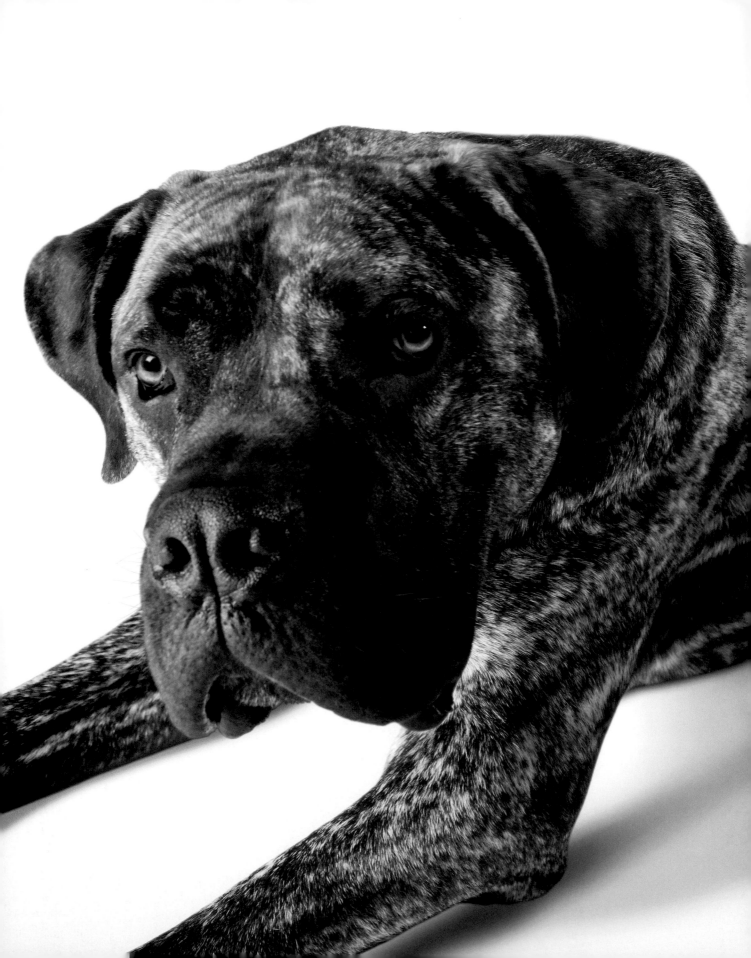

I'VE SEEN A LOOK IN DOGS' EYES, **A QUICKLY VANISHING LOOK OF AMAZED CONTEMPT,**
AND I AM CONVINCED THAT BASICALLY DOGS THINK HUMANS ARE NUTS.
JOHN STEINBECK

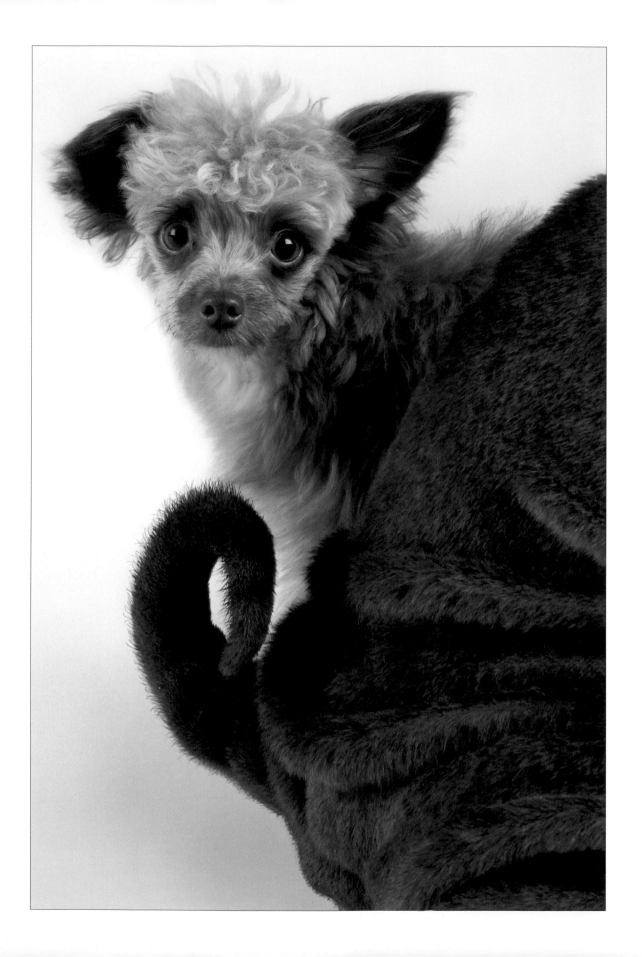

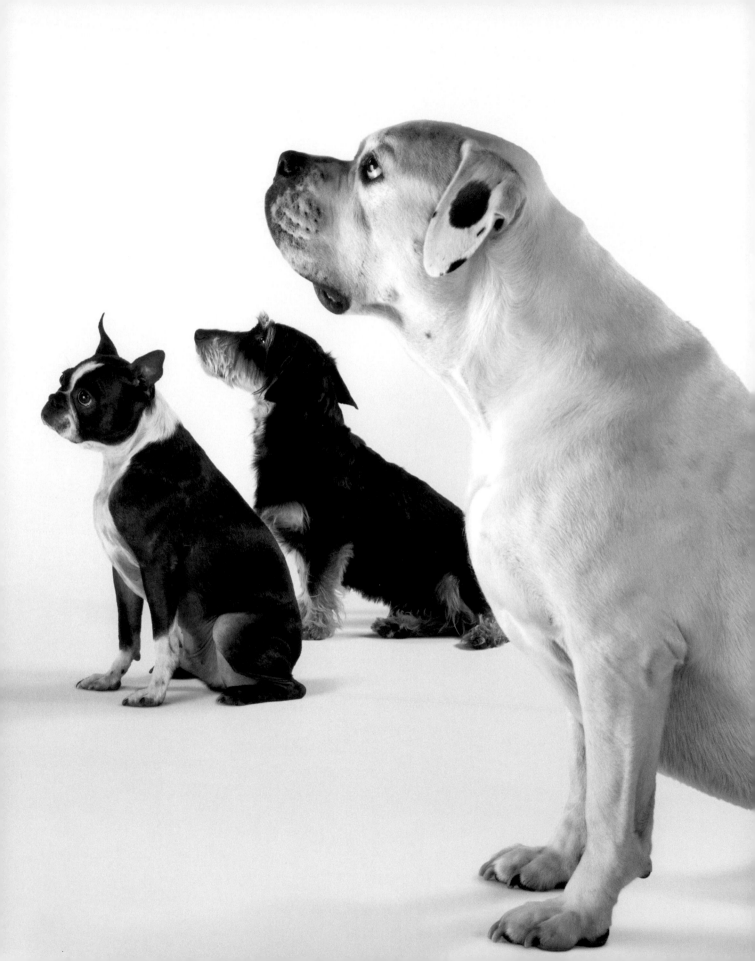

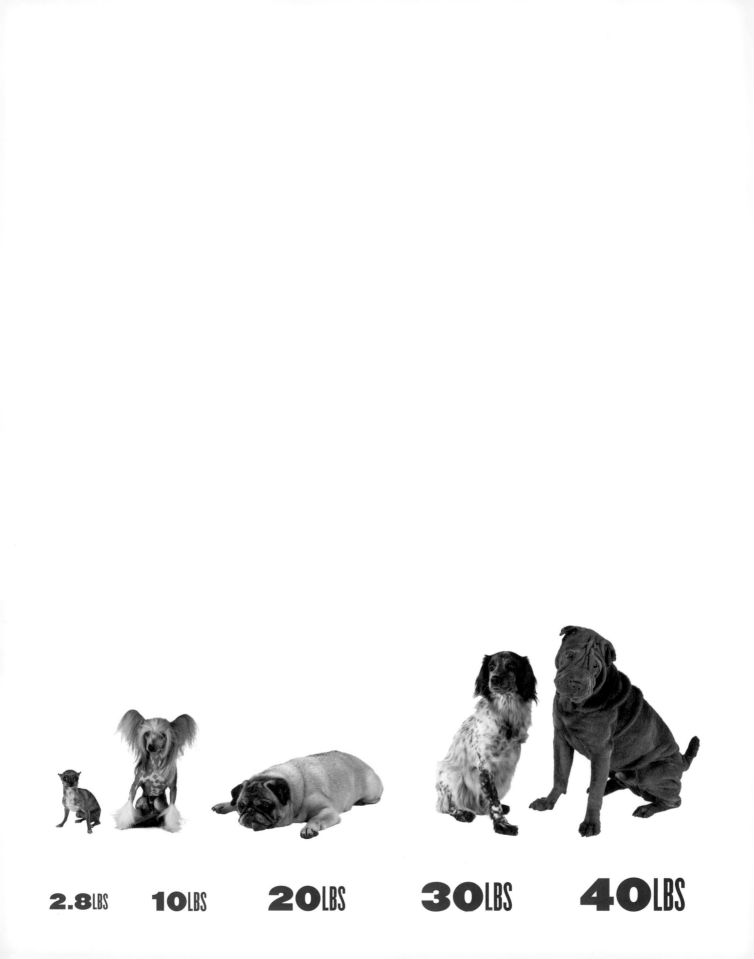

2.8LBS **10**LBS **20**LBS **30**LBS **40**LBS

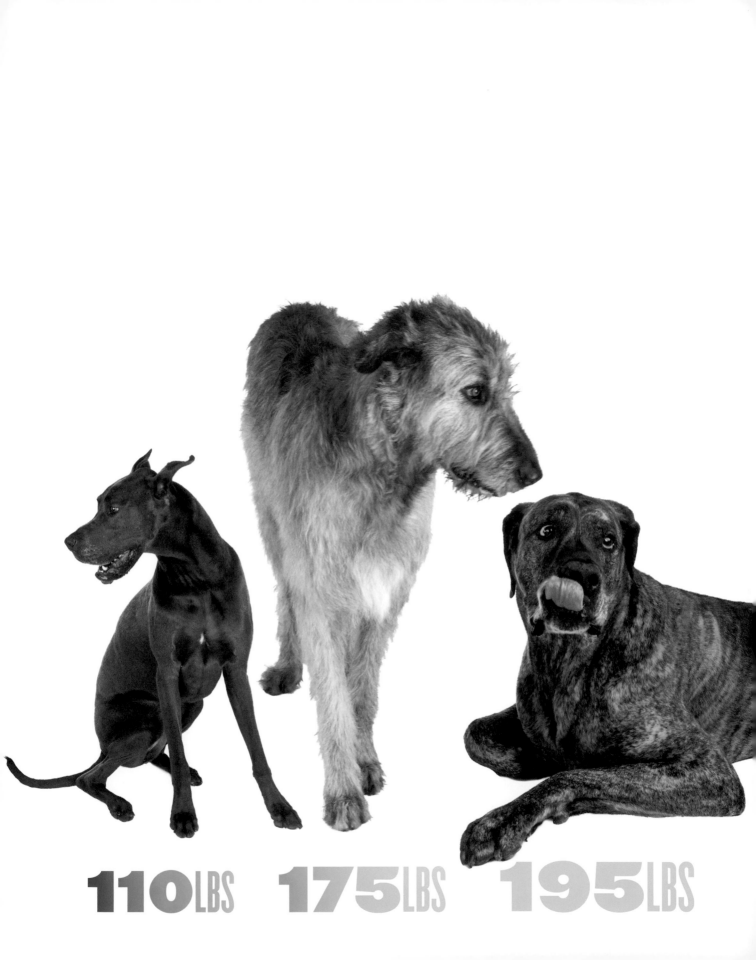

110LBS **175**LBS **195**LBS

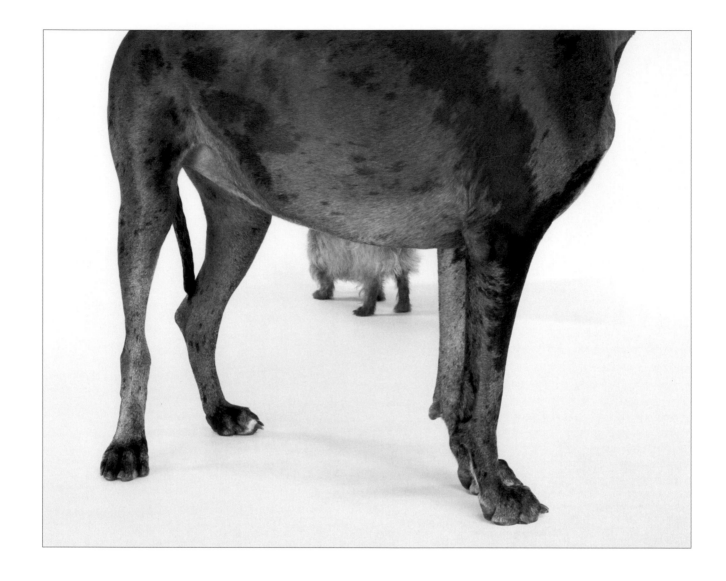

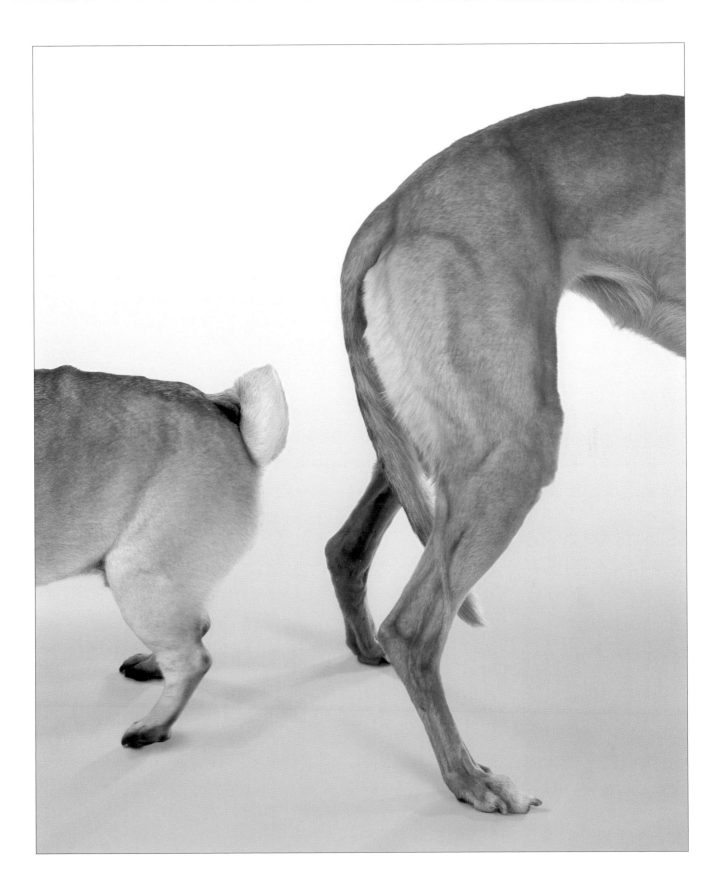

A DOG HAS THE SOUL OF A PHILOSOPHER.

PLATO

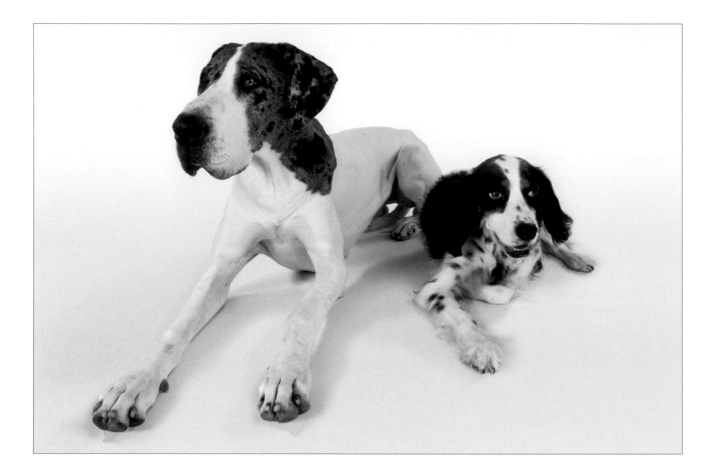

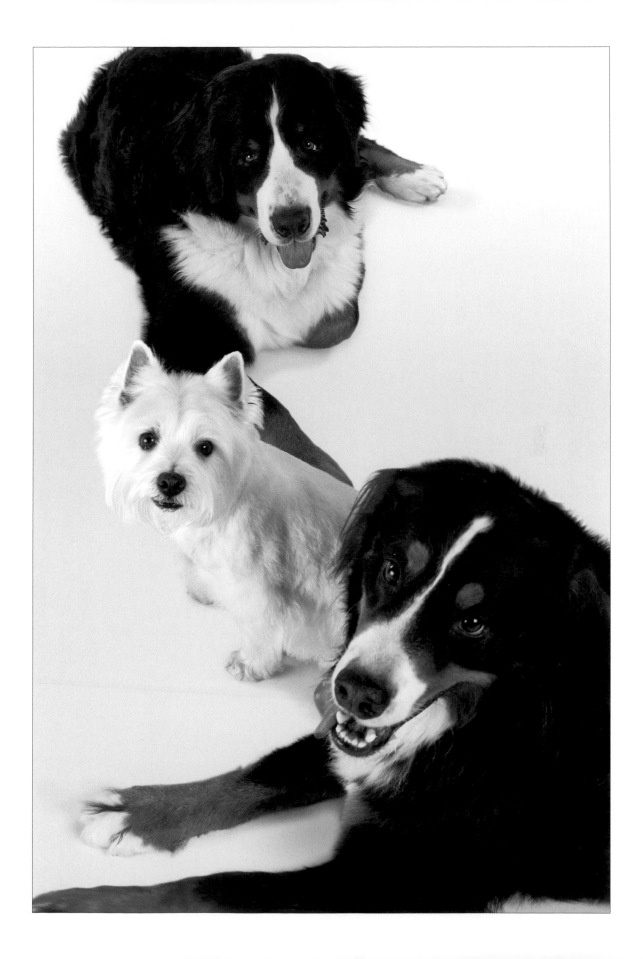

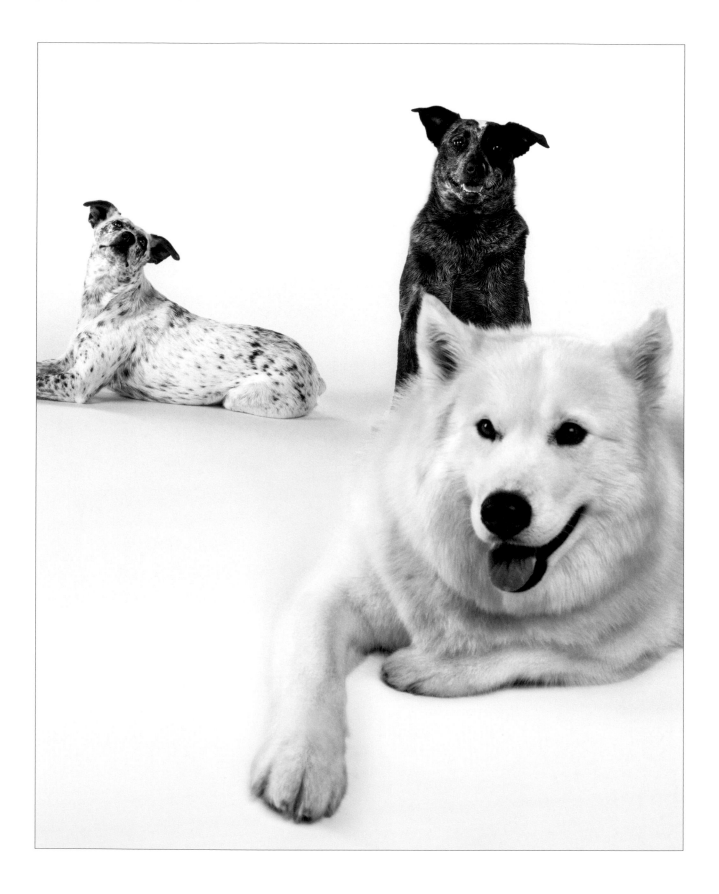

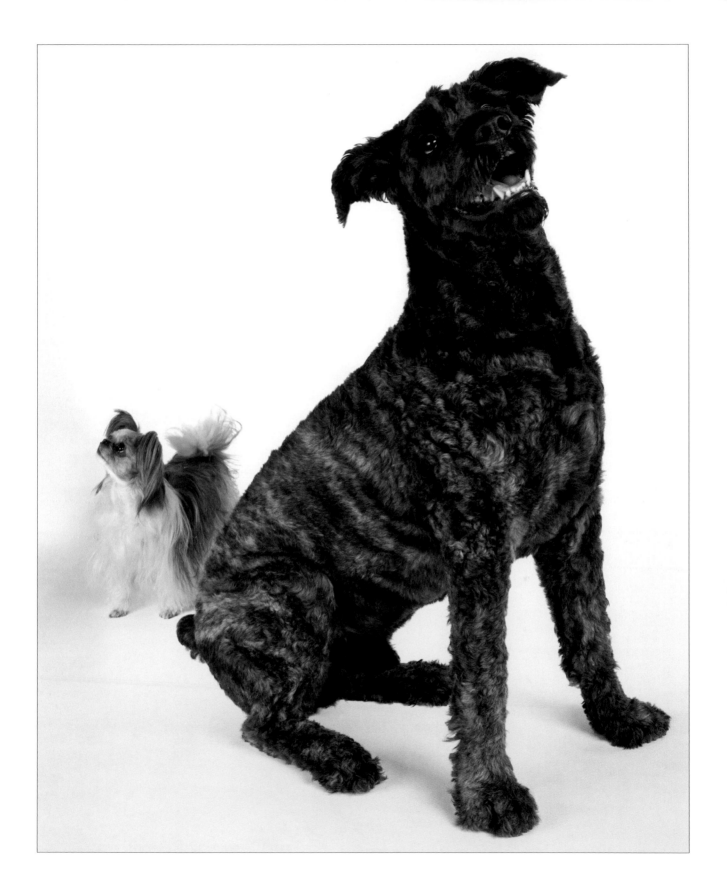

I HOPE IF DOGS TAKE OVER THE WORLD, AND THEY CHOOSE A KING, **THEY DON'T JUST GO BY SIZE,** BECAUSE I BET THERE ARE SOME CHIHUAHUAS WITH SOME GOOD IDEAS.

JACK HANDEY

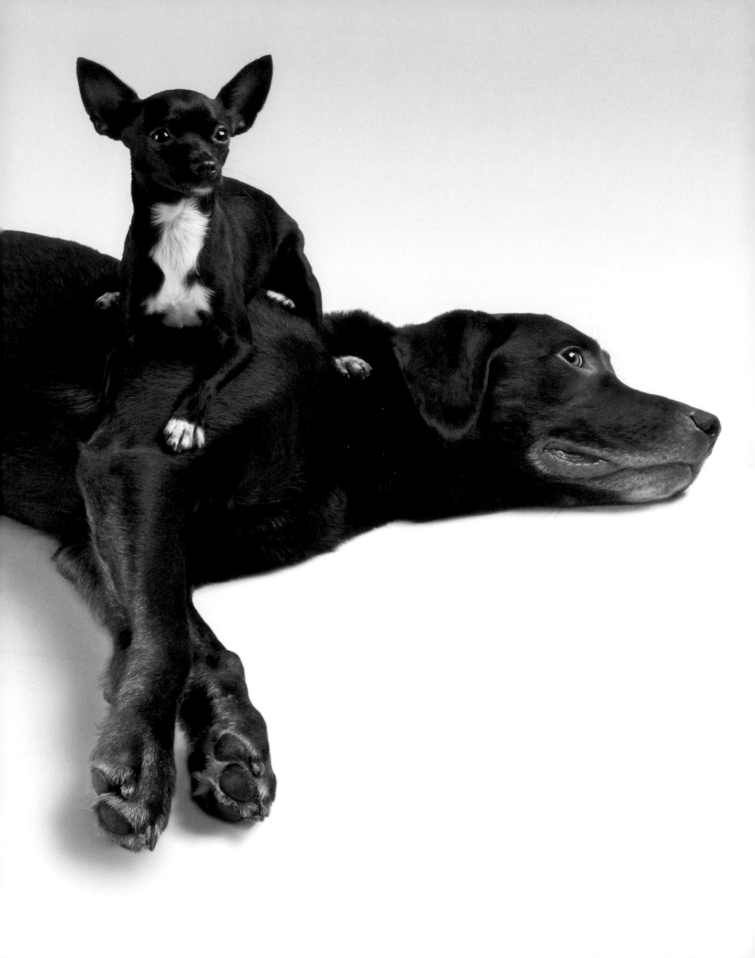

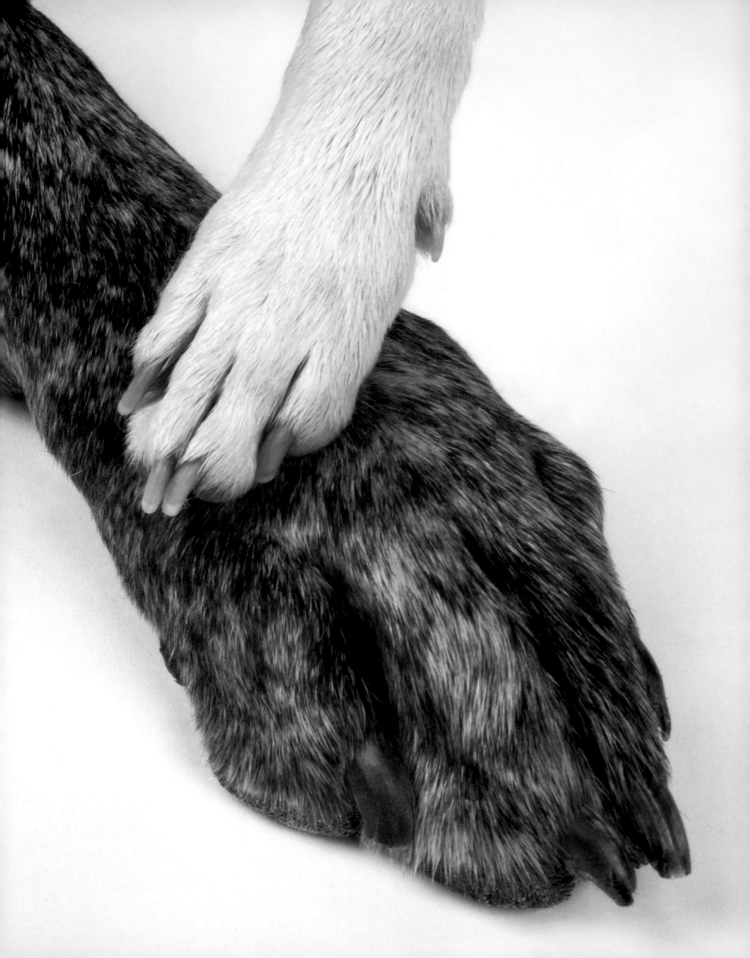

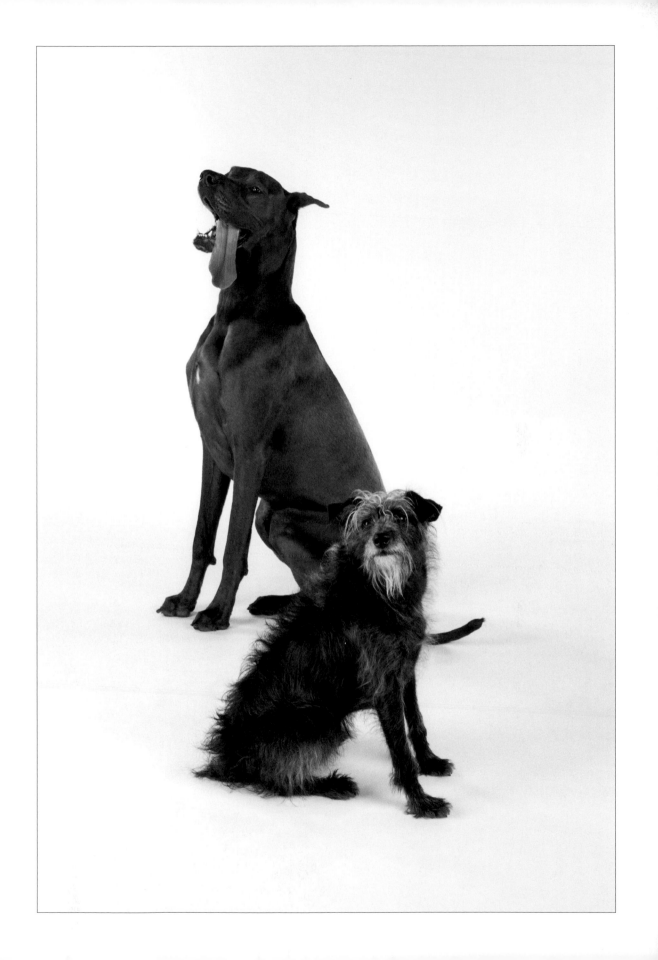

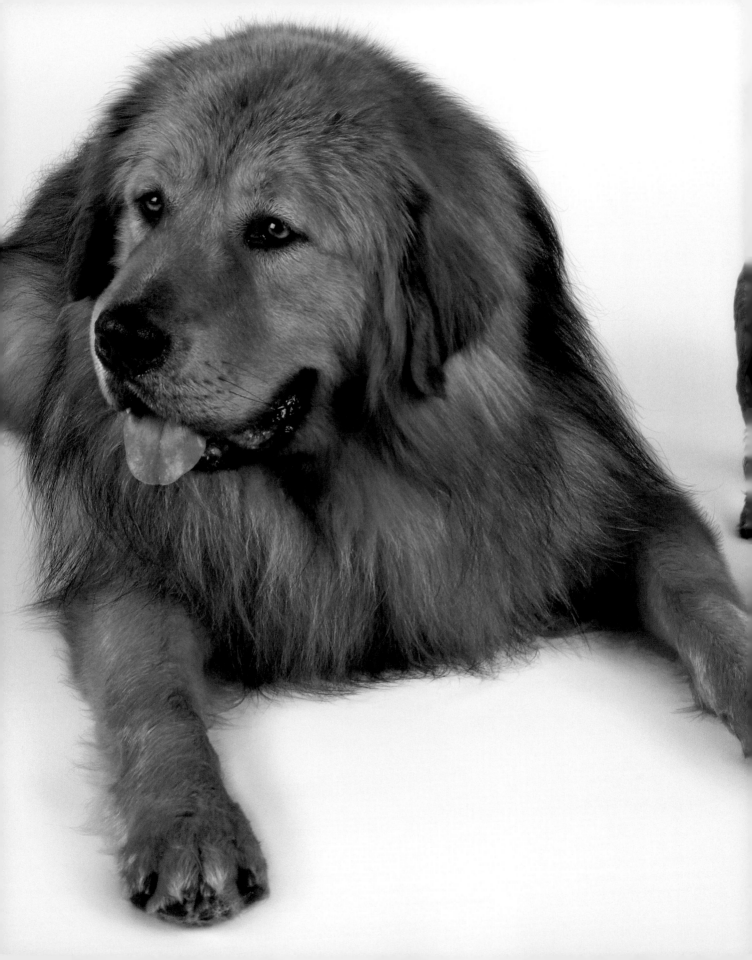

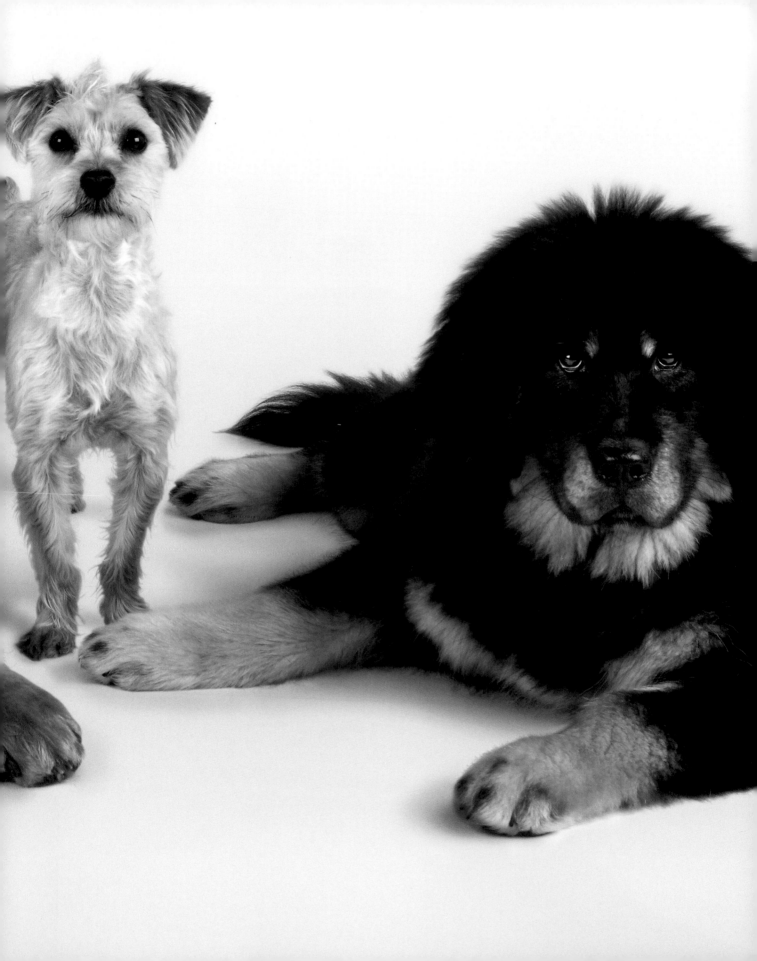

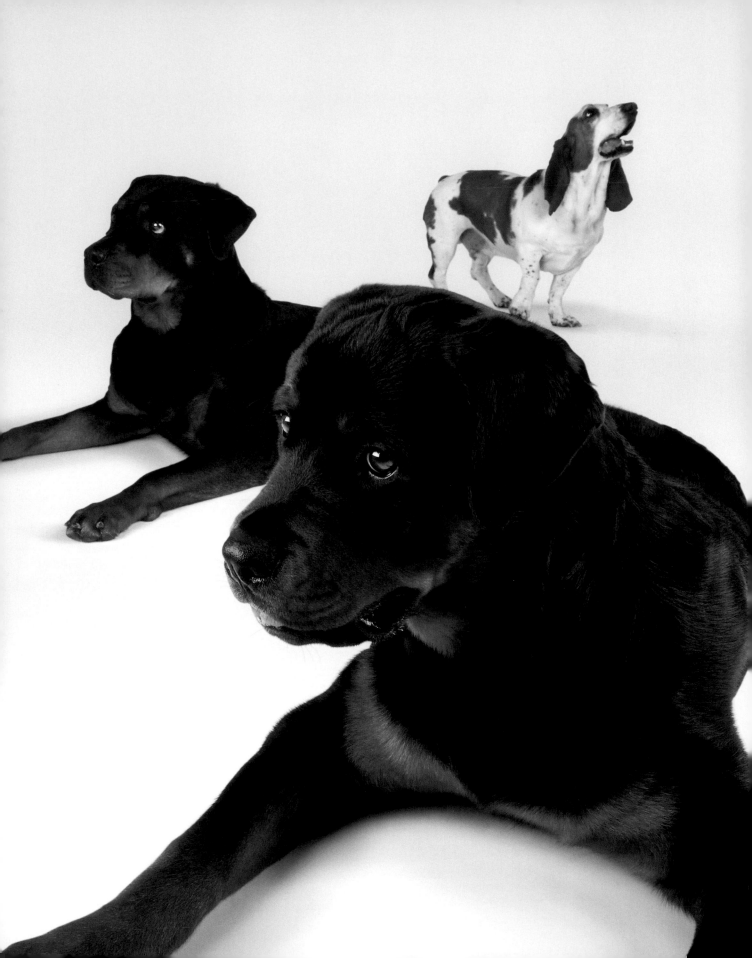

DOG A KIND OF ADDITIONAL OR SUBSIDIARY DEITY DESIGNED TO CATCH THE OVERFLOW AND SURPLUS OF THE WORLD'S WORSHIP.

AMBROSE BIERCE

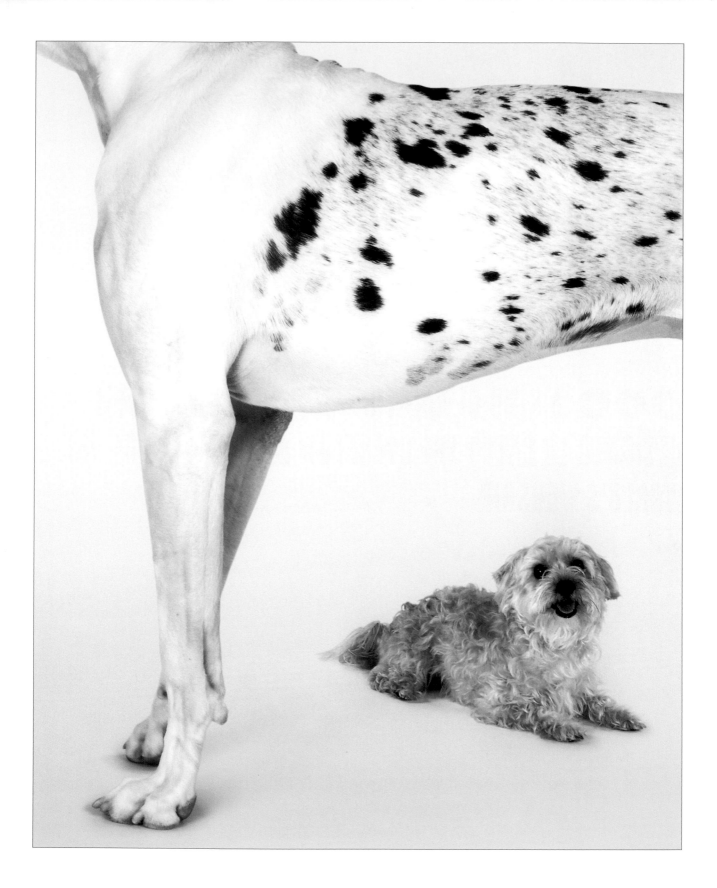

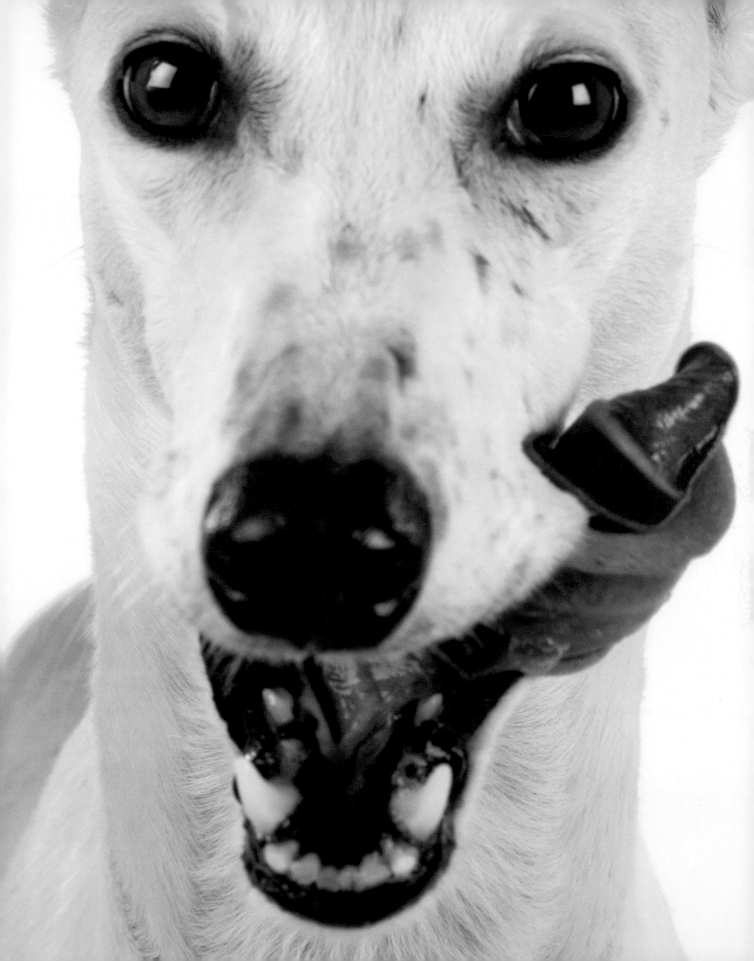

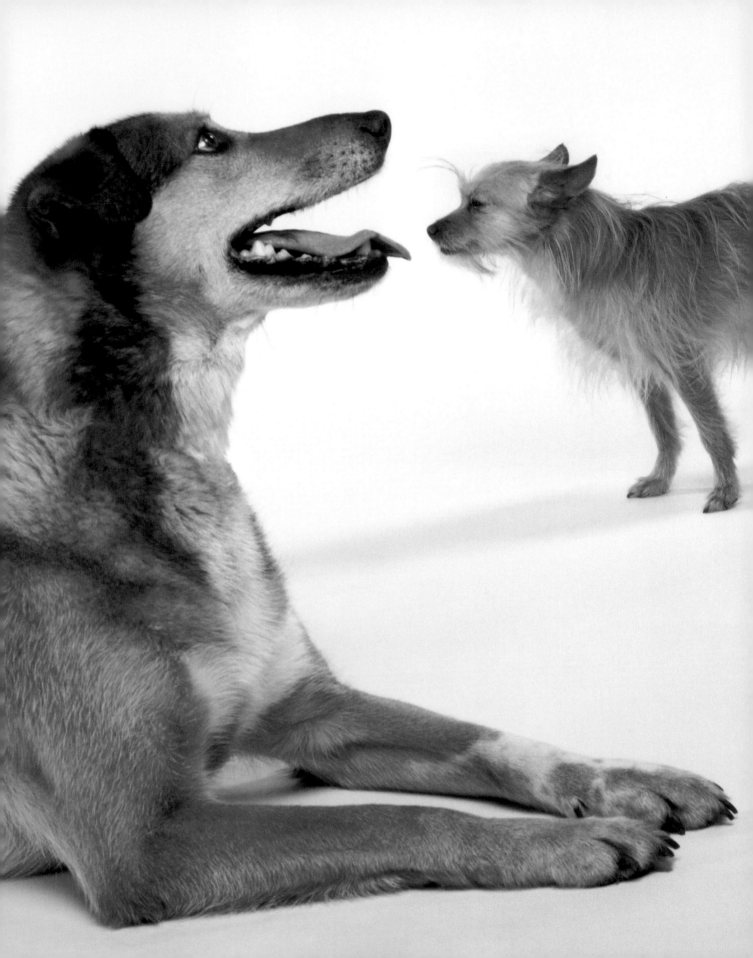

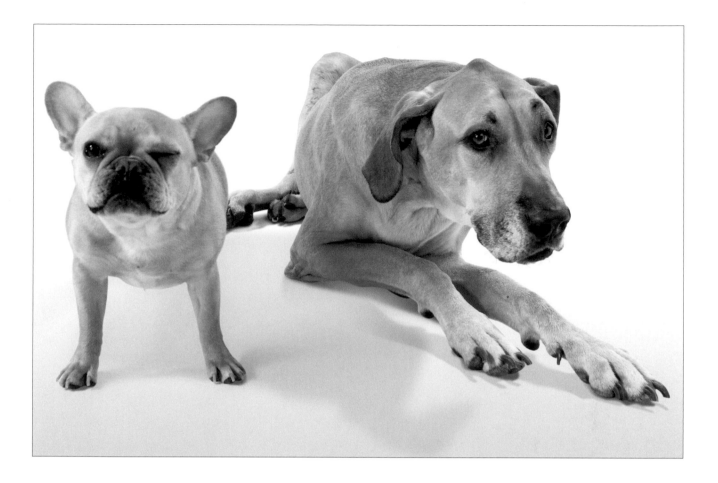

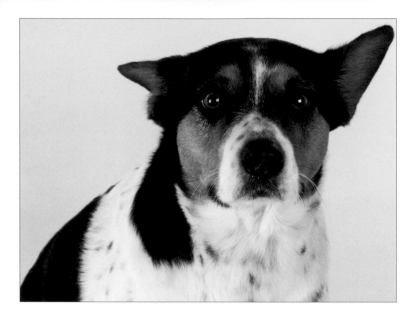
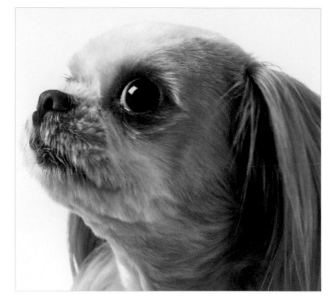
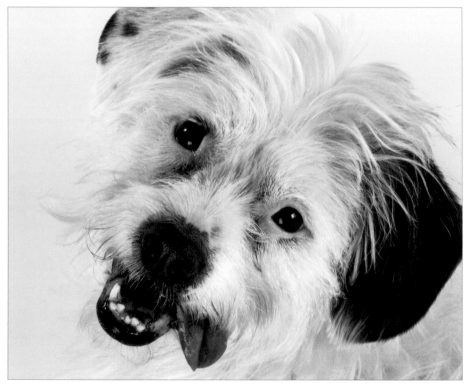
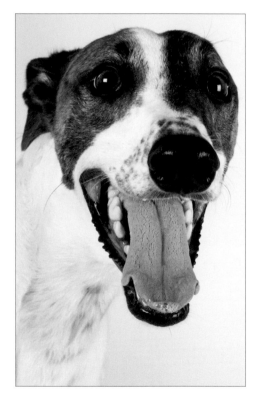
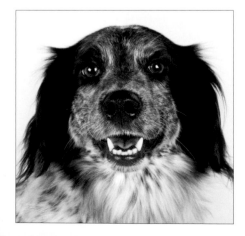
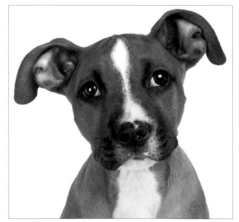
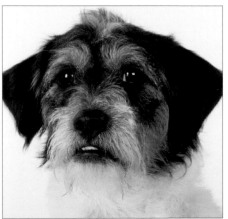

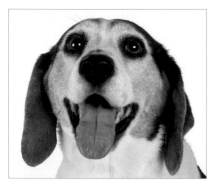
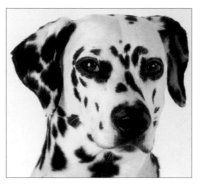
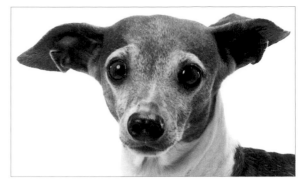
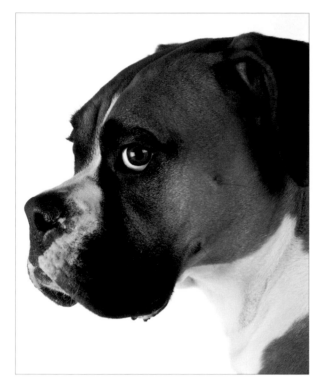
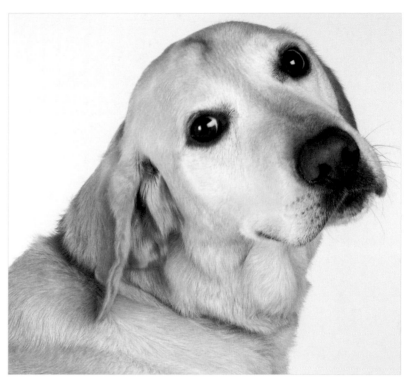
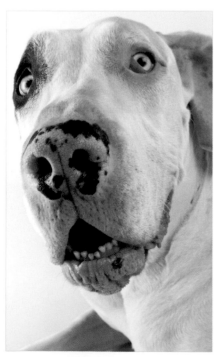
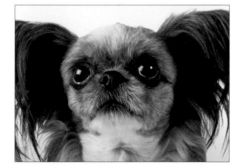
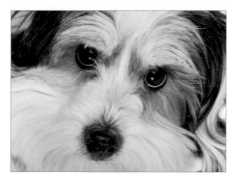
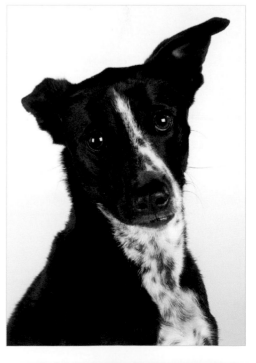

DOGS ARE OBSESSED WITH BEING HAPPY.

JAMES THURBER

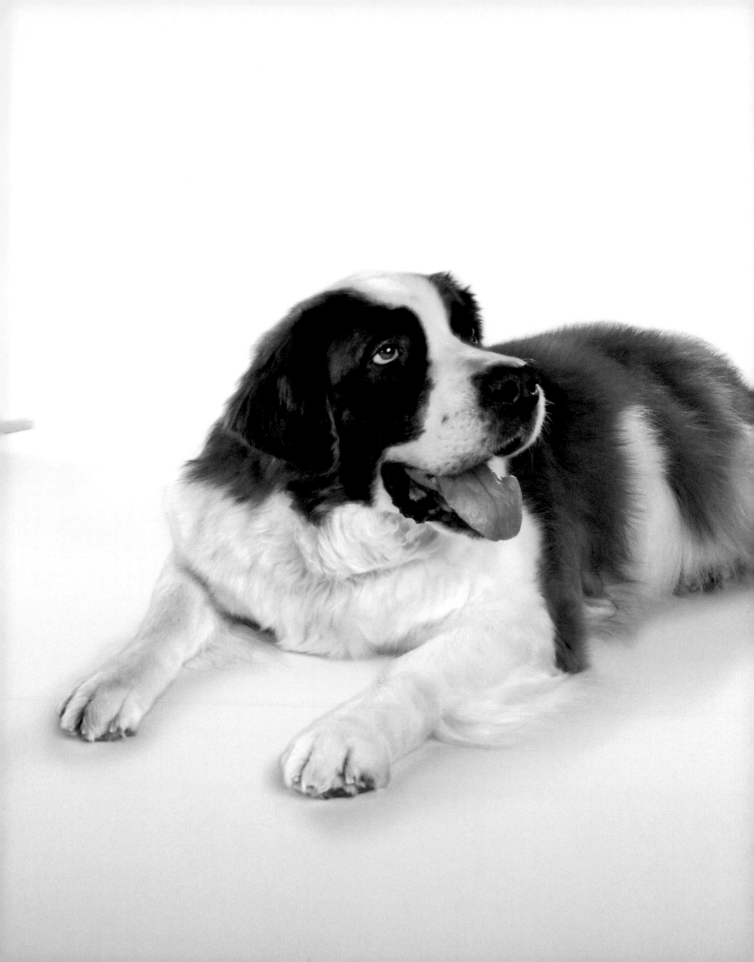

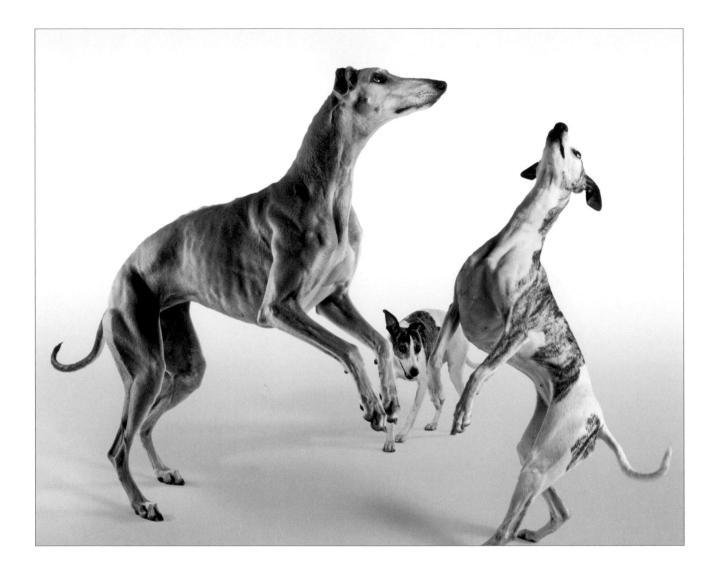

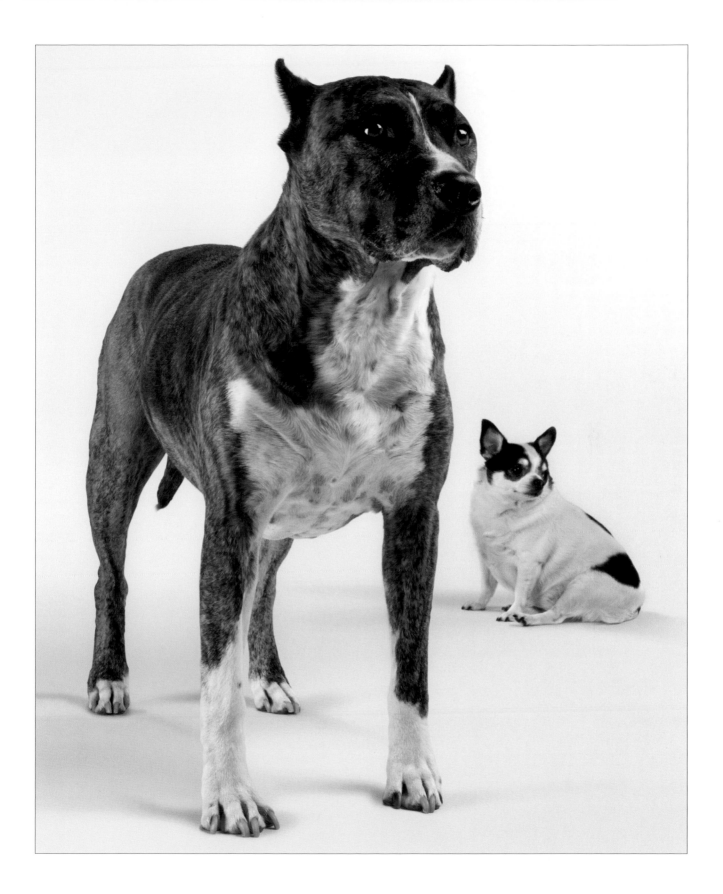

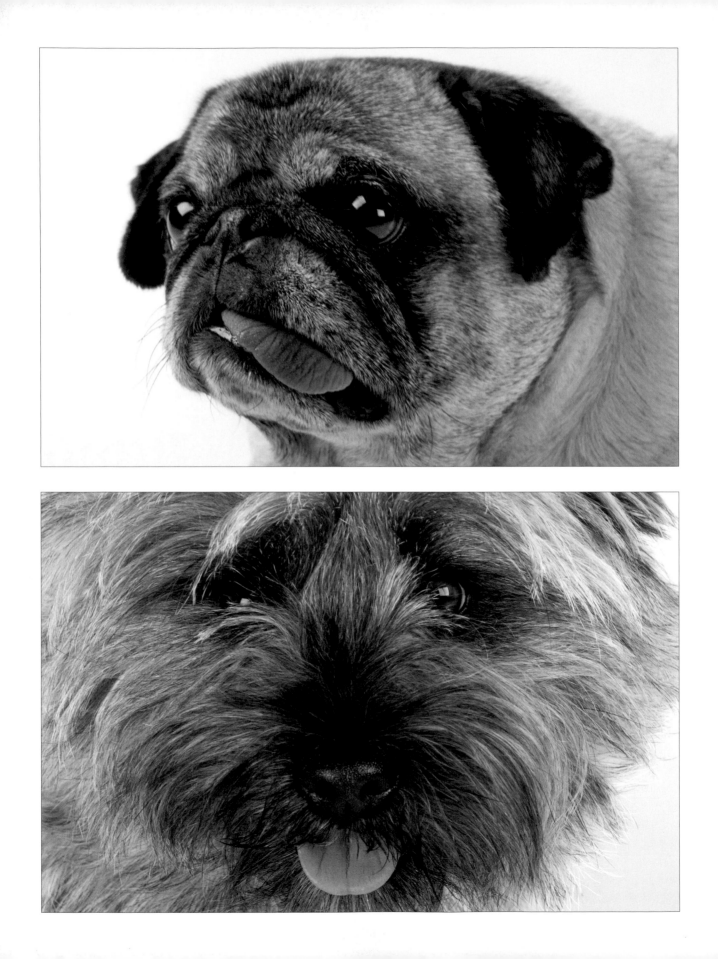

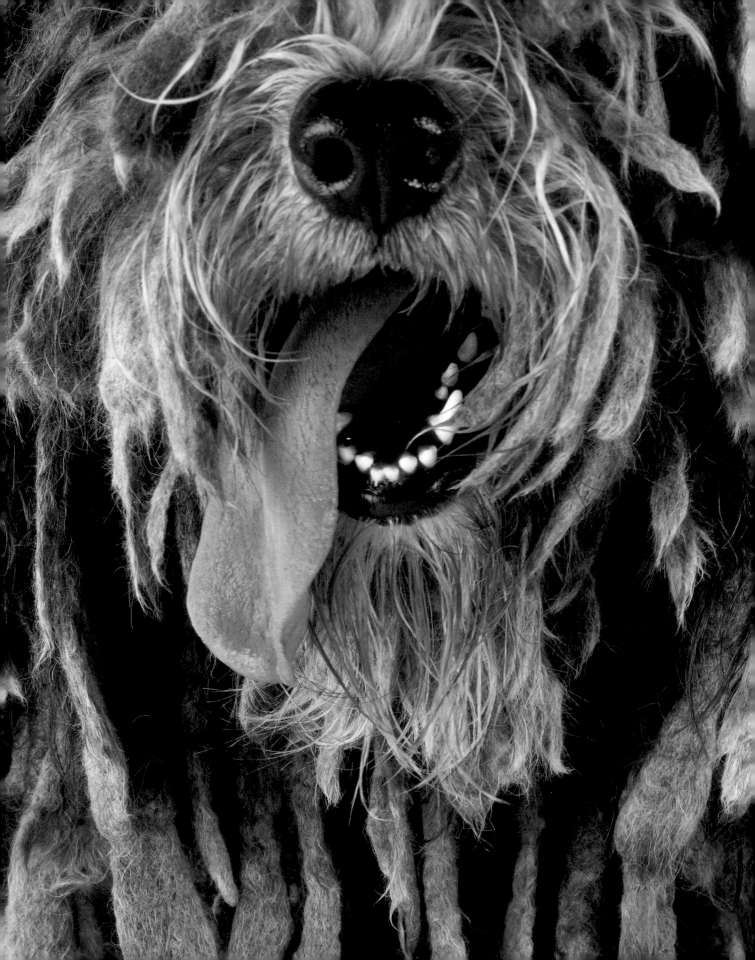

EVEN THE TINIEST POODLE OR CHIHUAHUA IS STILL A WOLF AT HEART.

DOROTHY HINSHAW PATENT

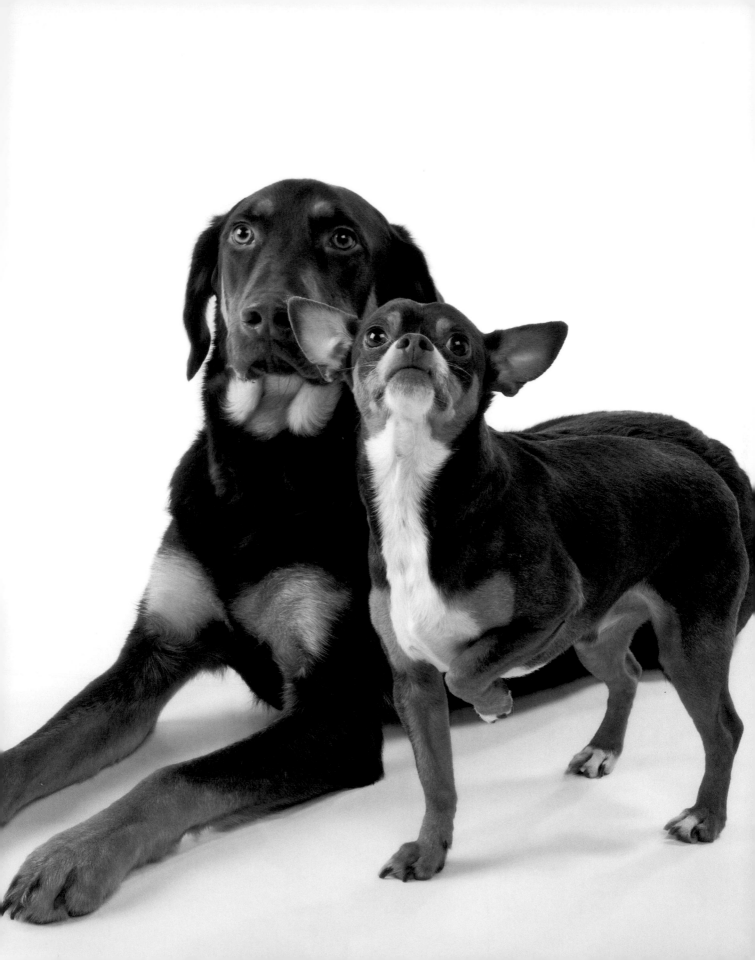

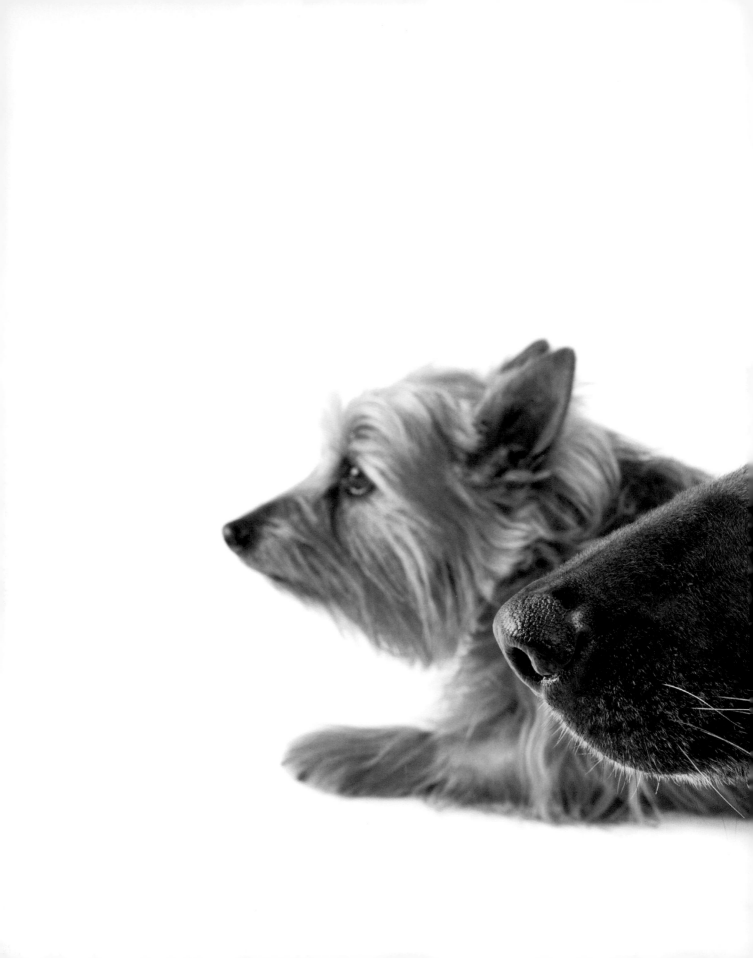

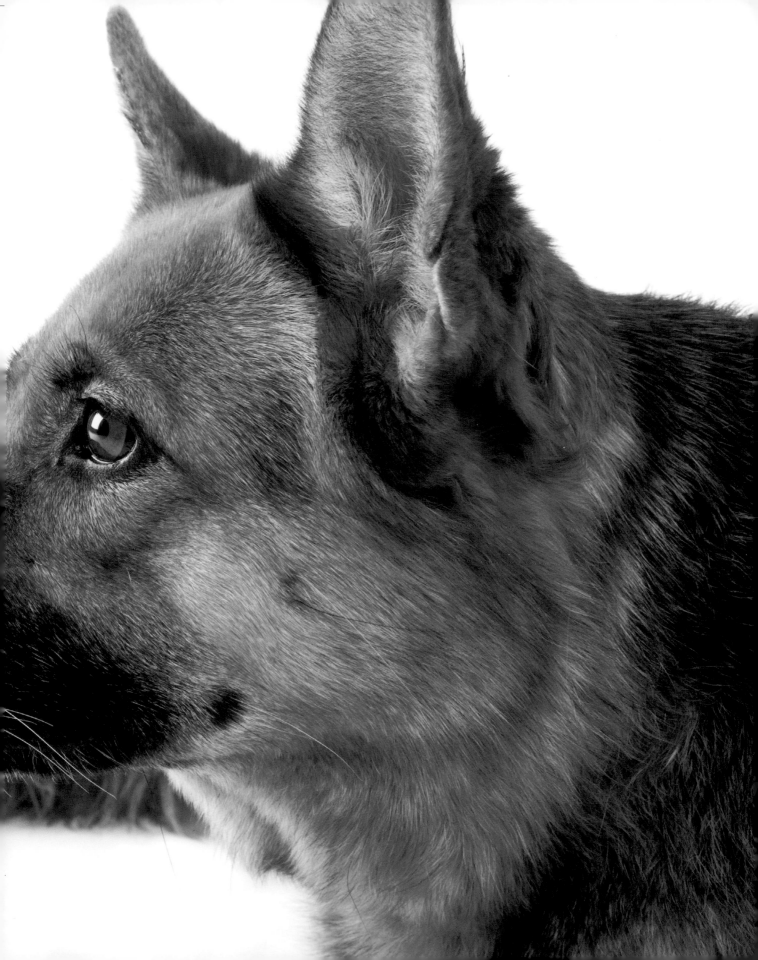

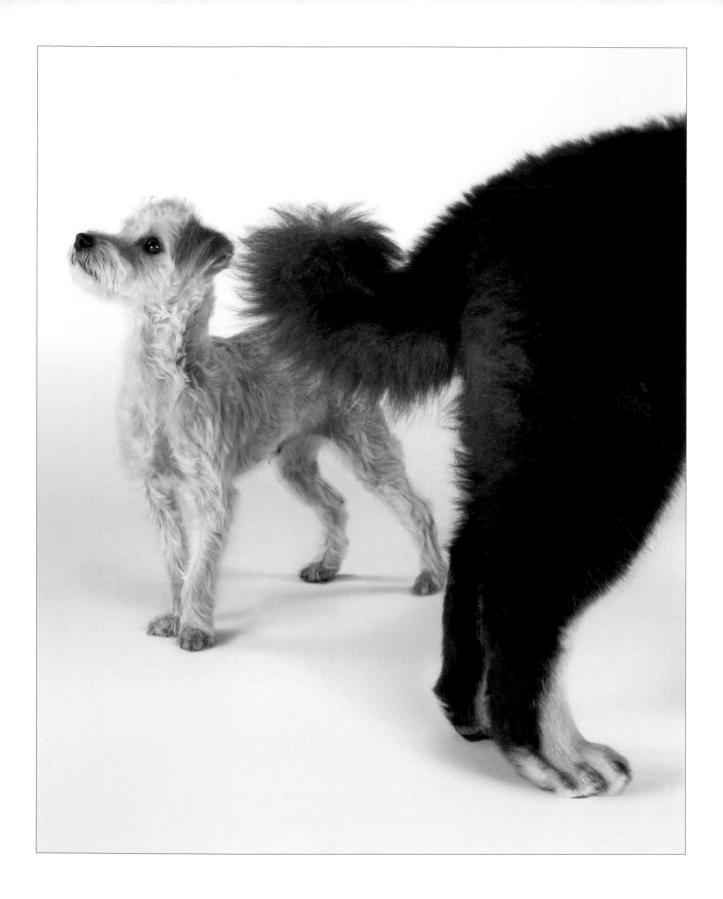

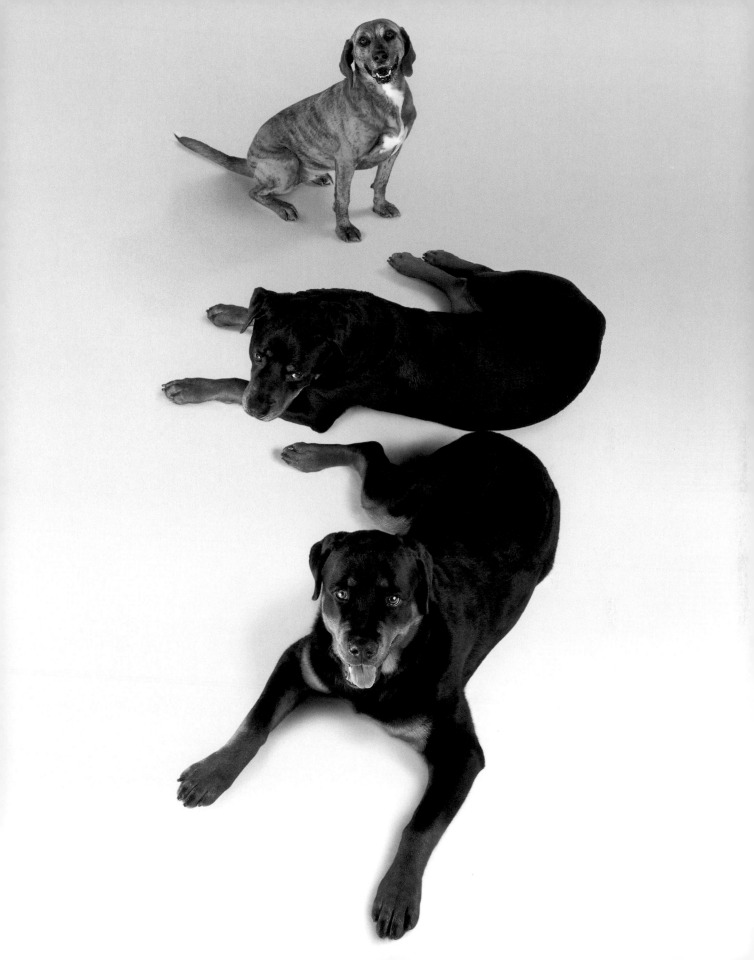

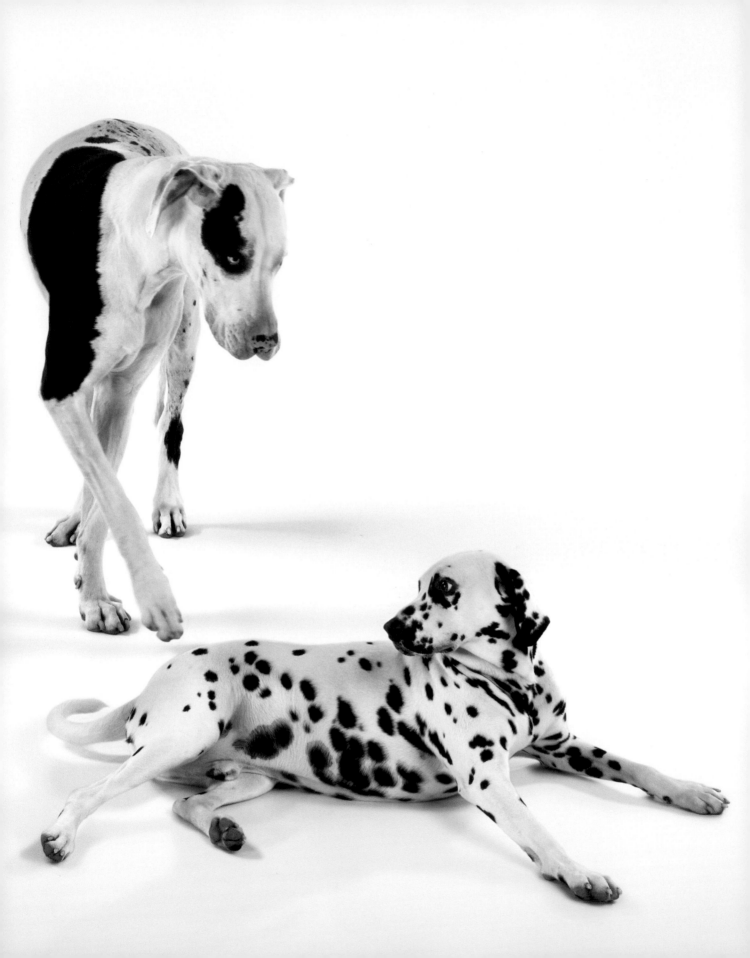

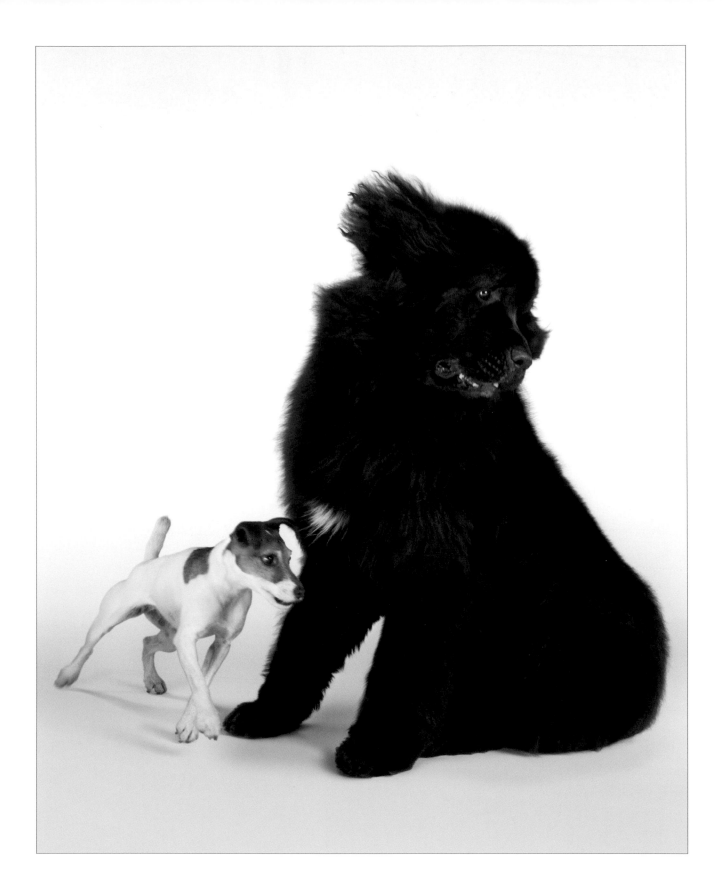

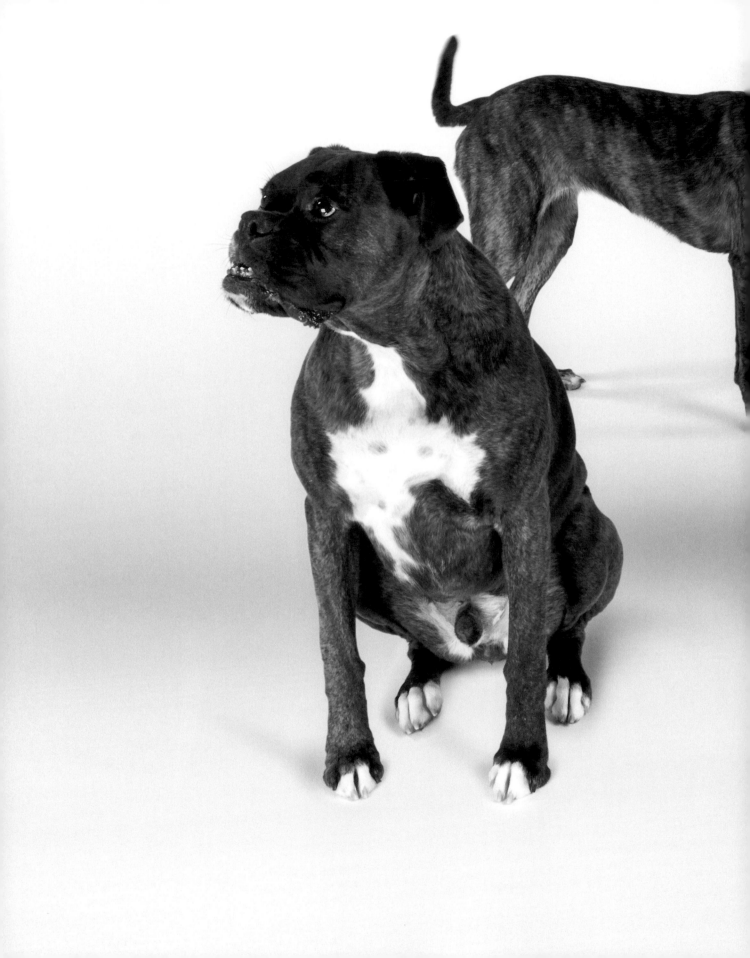

ALL KNOWLEDGE,

THE TOTALITY OF ALL QUESTIONS AND ALL ANSWERS IS CONTAINED IN THE DOG.

FRANZ KAFKA

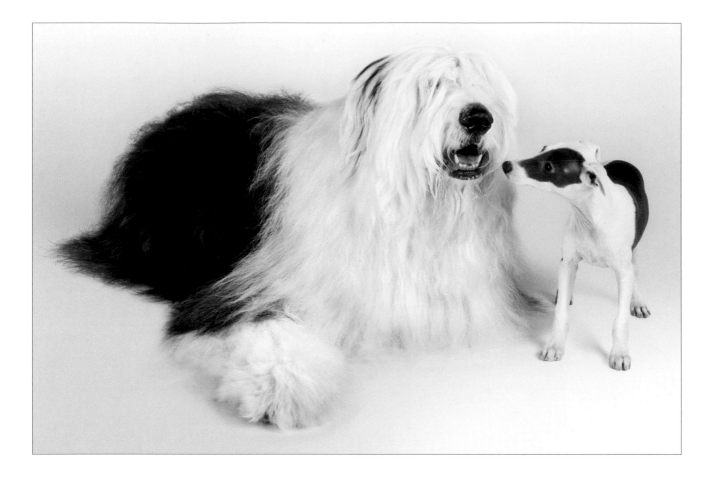

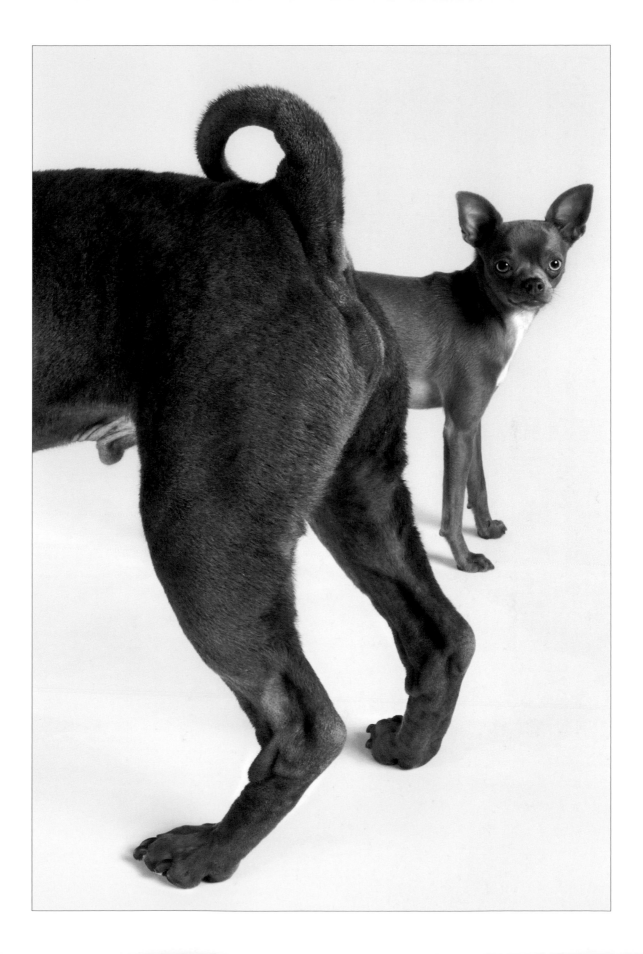

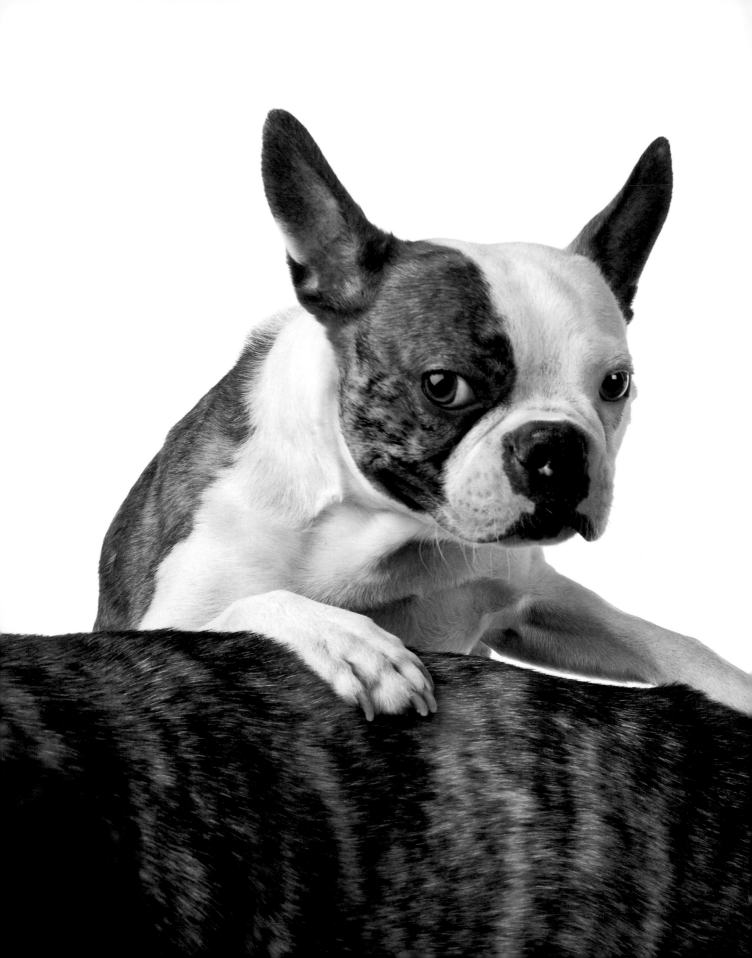

SIZE MATTERS NOT. LOOK AT ME.
JUDGE ME BY SIZE, DO YOU?

YODA

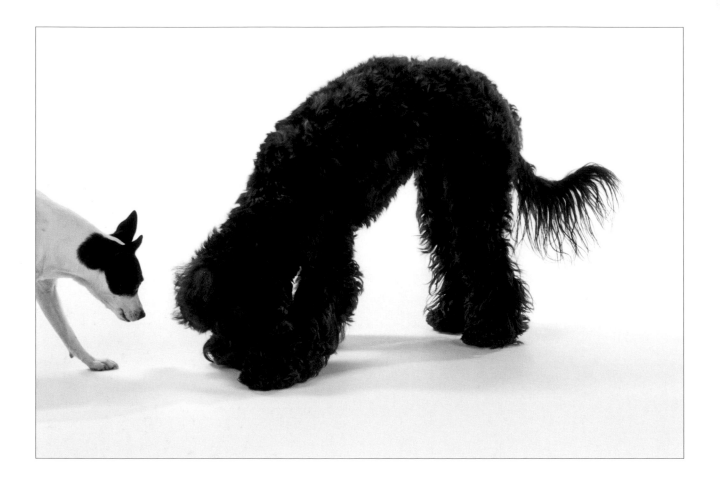

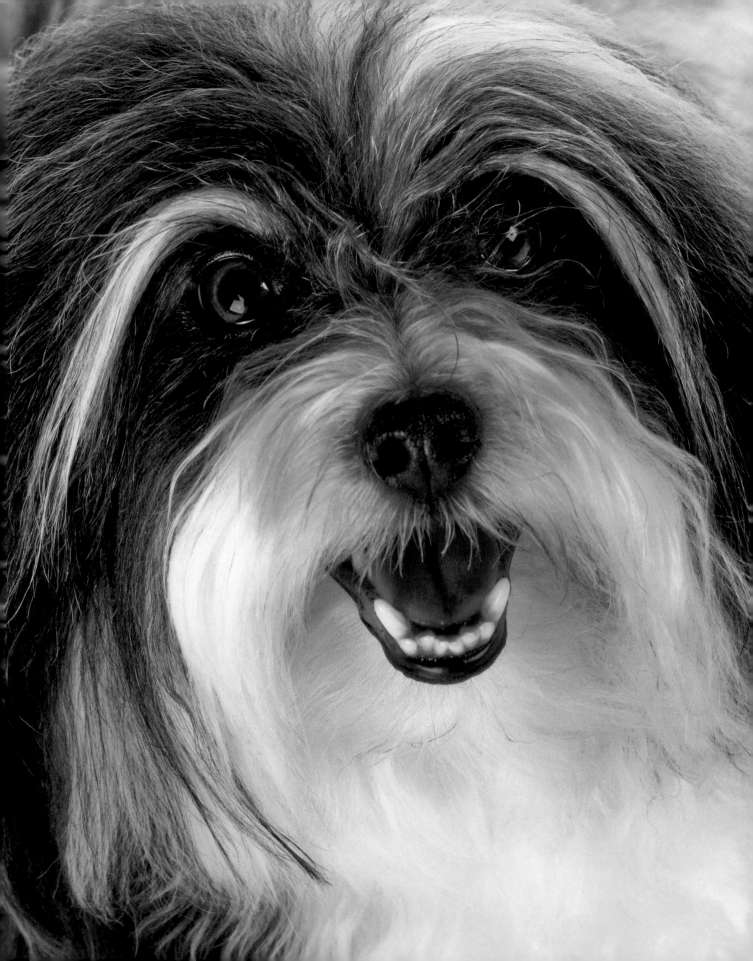

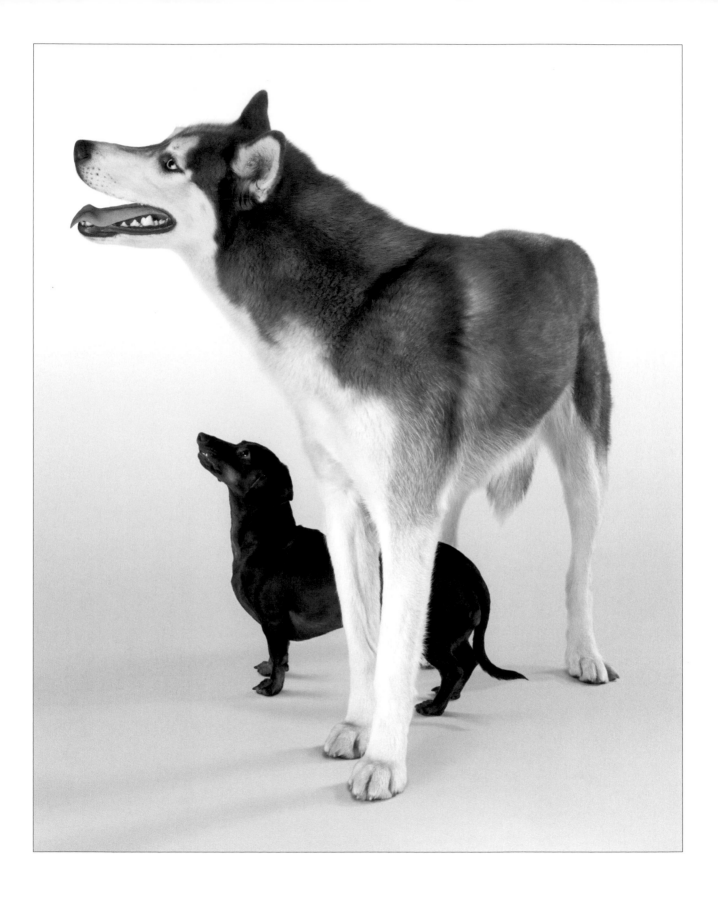

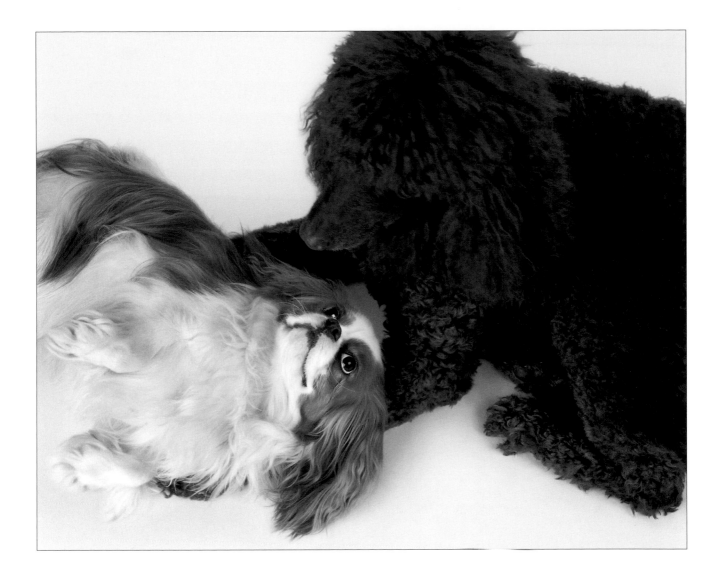

SMALL**MEDIUM**LARGE

4 LBS / 1.8 KGS
ROCCO
CHIHUAHUA

8 LBS / 3.6 KGS
DELPHI
PAPILLON

12 LBS / 5.4 KGS
DAYDEN
DACHSHUND

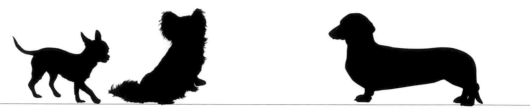

28 LBS / 12.7 KGS
PENNY
MIXED BREED

40 LBS / 18.2 KGS
VENUS
MIXED BREED

45 LBS / 20.4 KGS
HOBBS
WHIPPET

70 LBS / 31.7 KGS
PILLAR
BOUVIER DES FLANDRES

60 LBS / 27.2 KGS
ZOE
GOLDEN RETRIEVER

82 LBS / 37.3 KGS
JOSIE
ROTTWEILER

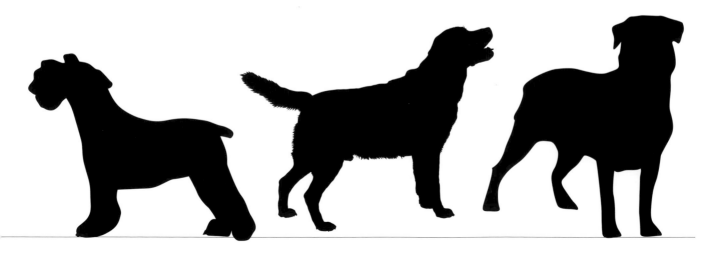

18 LBS / 8.2 KGS
LUCY
BEAGLE

25 LBS / 11.4 KGS
TULLY
WELSH CORGI

23 LBS / 10.5 KGS
RUBY
PUG

50 LBS / 22.6 KGS
BURGER
ENGLISH BULLDOG

55 LBS / 25 KGS
WINSLOW
BASSET HOUND

70 LBS / 31.7 KGS
HENRY
AMERICAN FOXHOUND

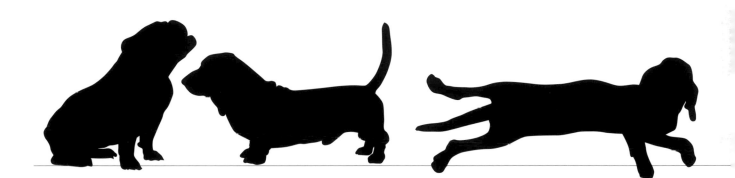

110 LBS / 49.8 KGS
ELLE WOODS
GREAT DANE

160 LBS / 72.5 KGS
KATO
MASTIFF

175 LBS / 79.3 KGS
ULF
IRISH WOLFHOUND

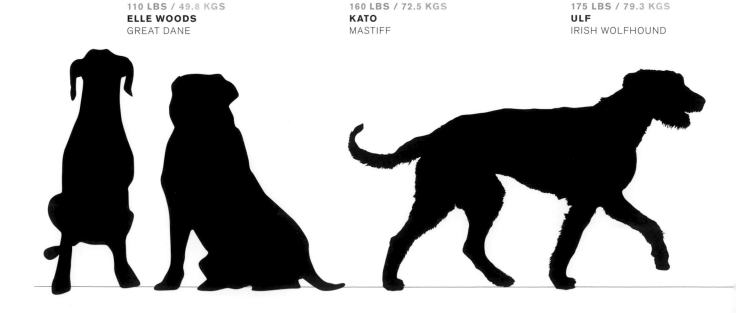

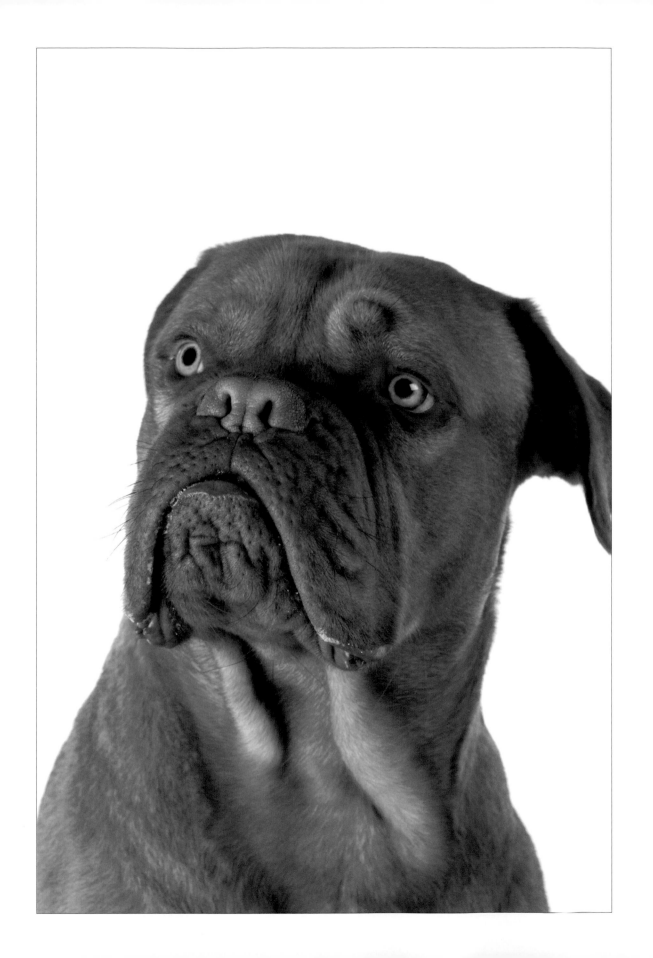

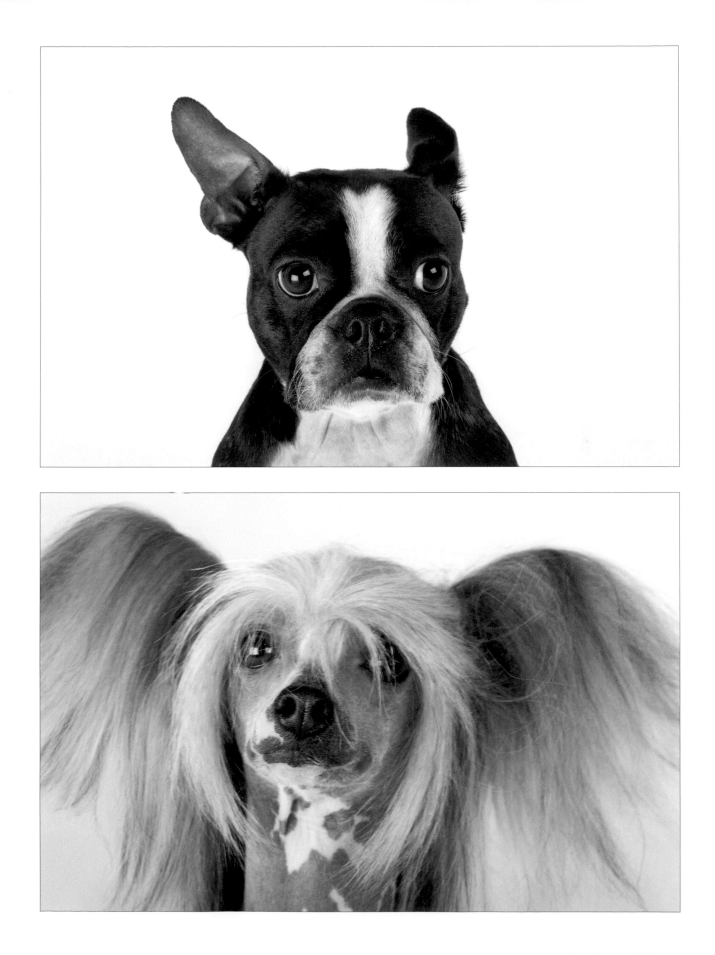

I WONDER IF OTHER DOGS THINK POODLES ARE MEMBERS OF A WEIRD RELIGIOUS CULT.

RITA RUDNER

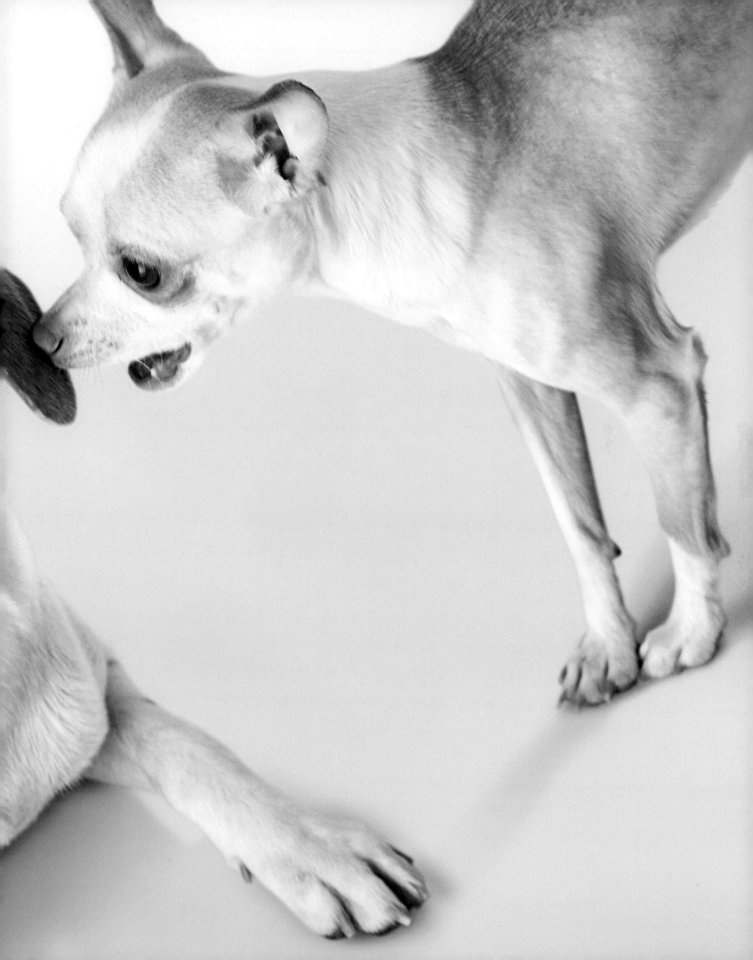

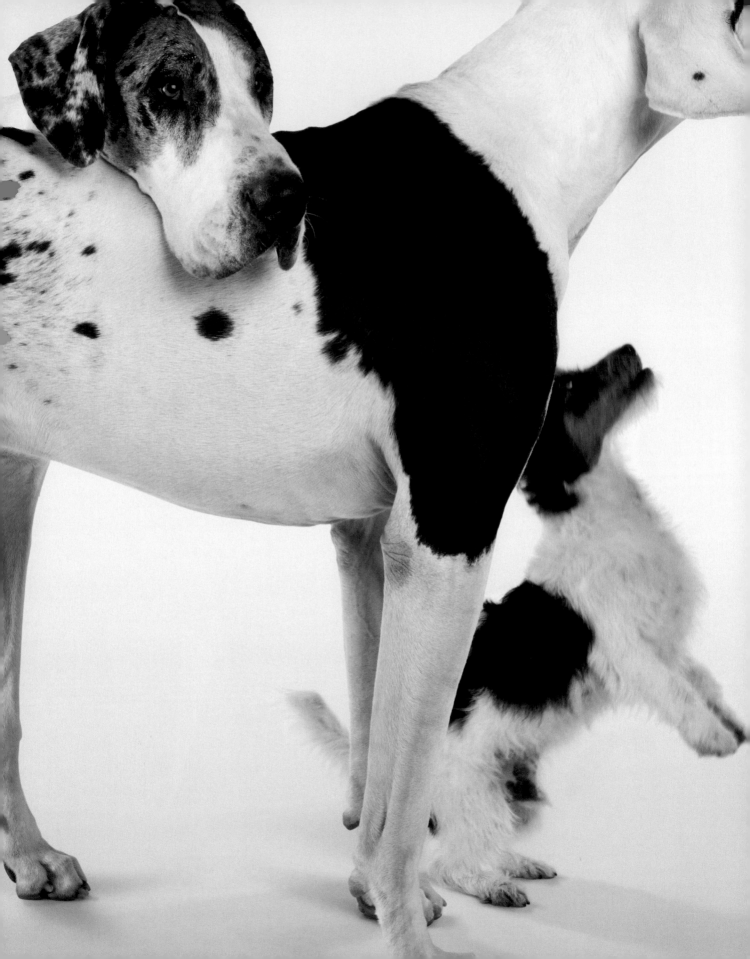

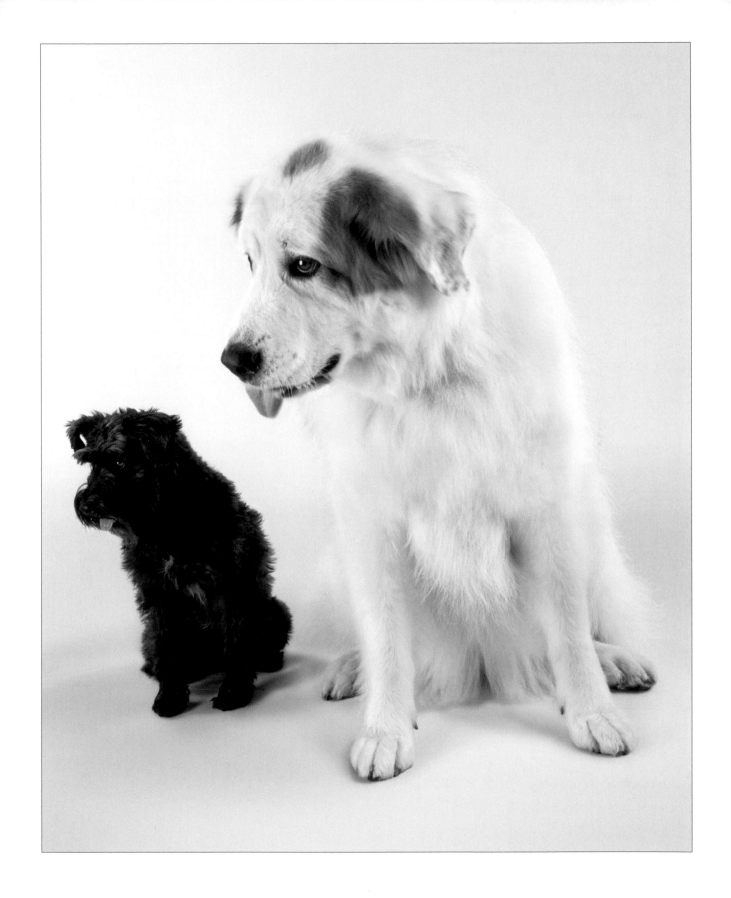

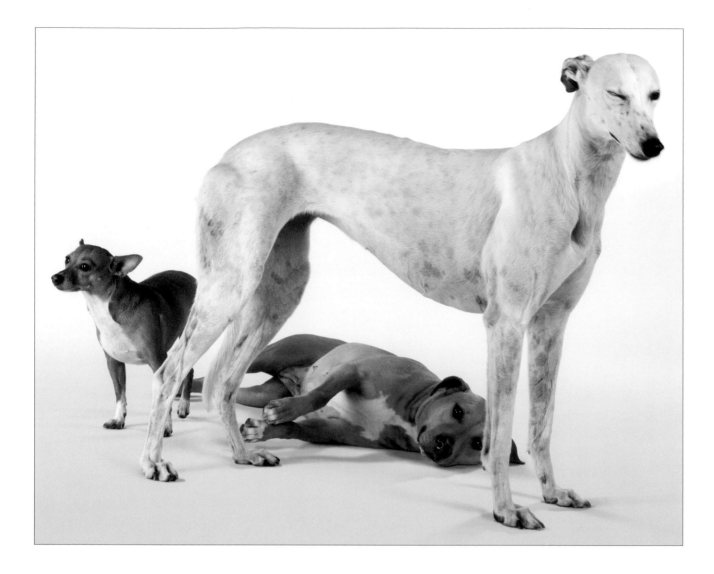

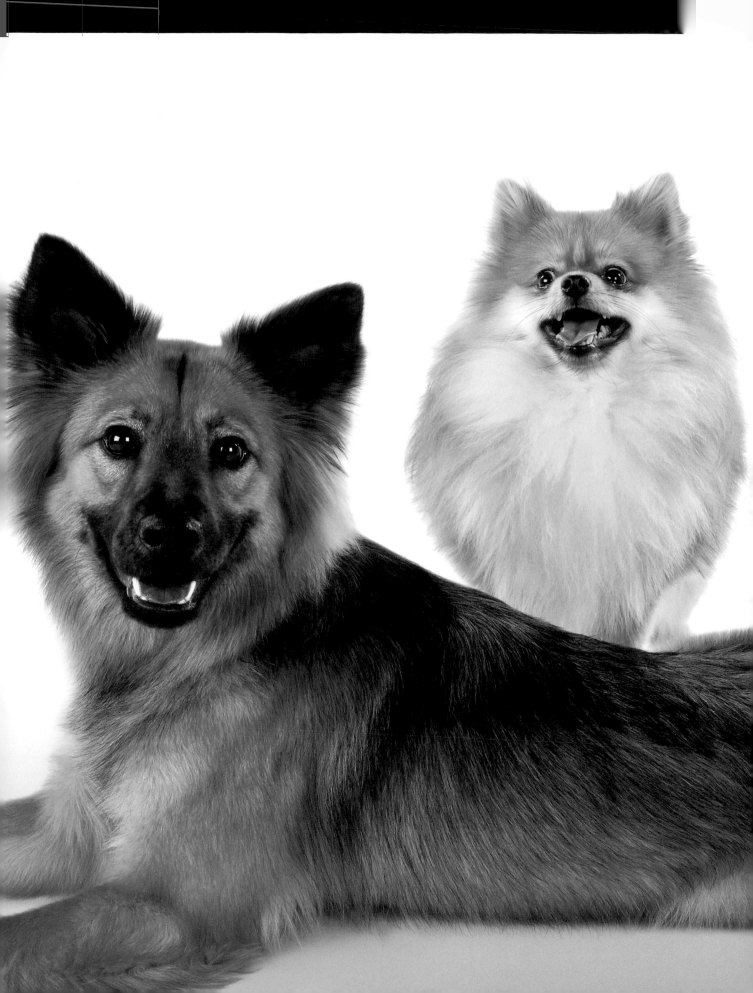

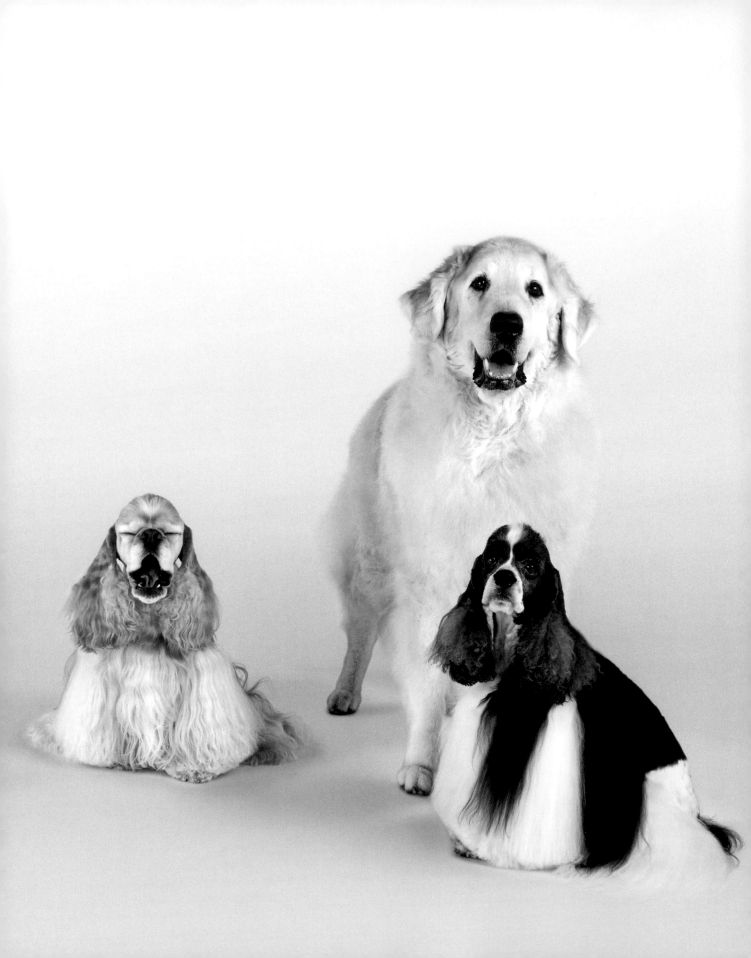

ACQUIRING A DOG MAY BE THE ONLY OPPORTUNITY A HUMAN EVER HAS TO CHOOSE A RELATIVE.

MORDECAI SIEGAL

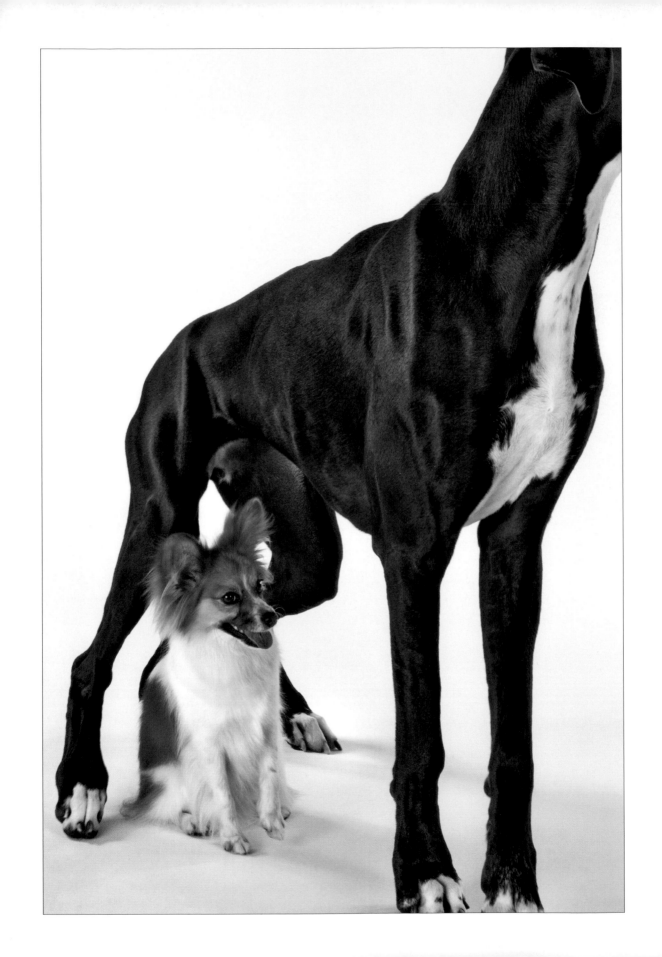

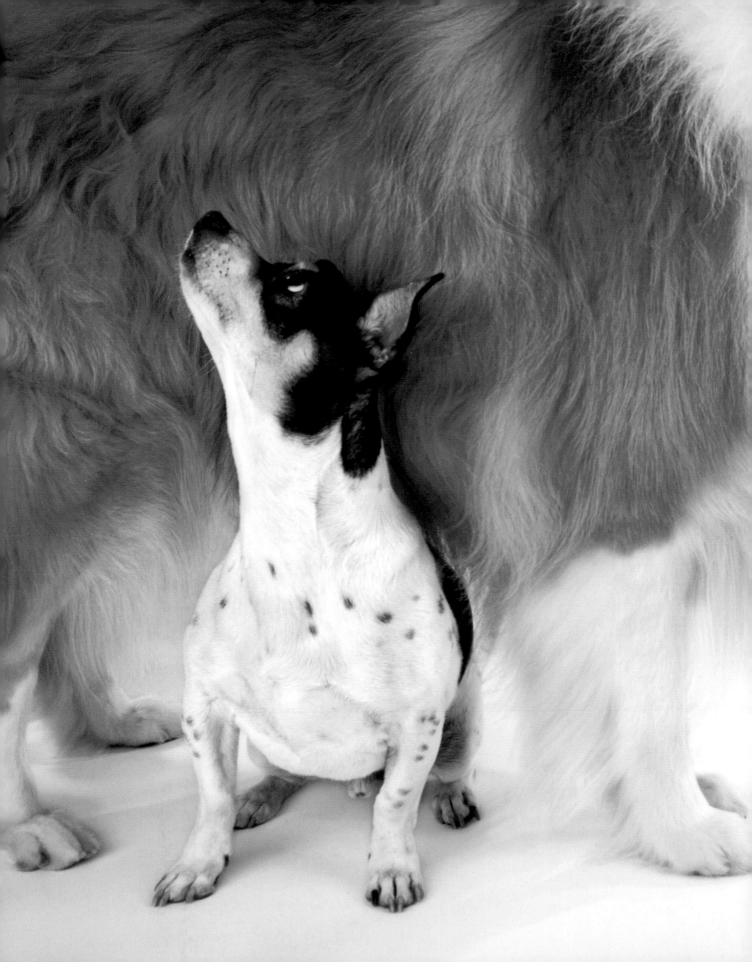

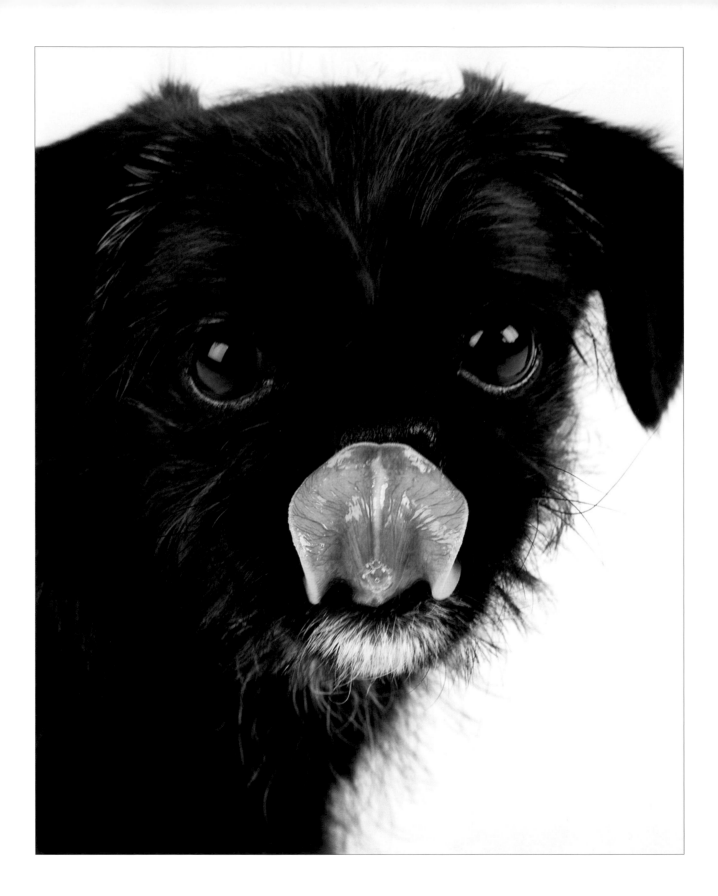

I THINK DOGS ARE THE MOST AMAZING CREATURES; THEY GIVE UNCONDITIONAL LOVE. FOR ME THEY ARE THE ROLE MODEL FOR BEING ALIVE.

GILDA RADNER

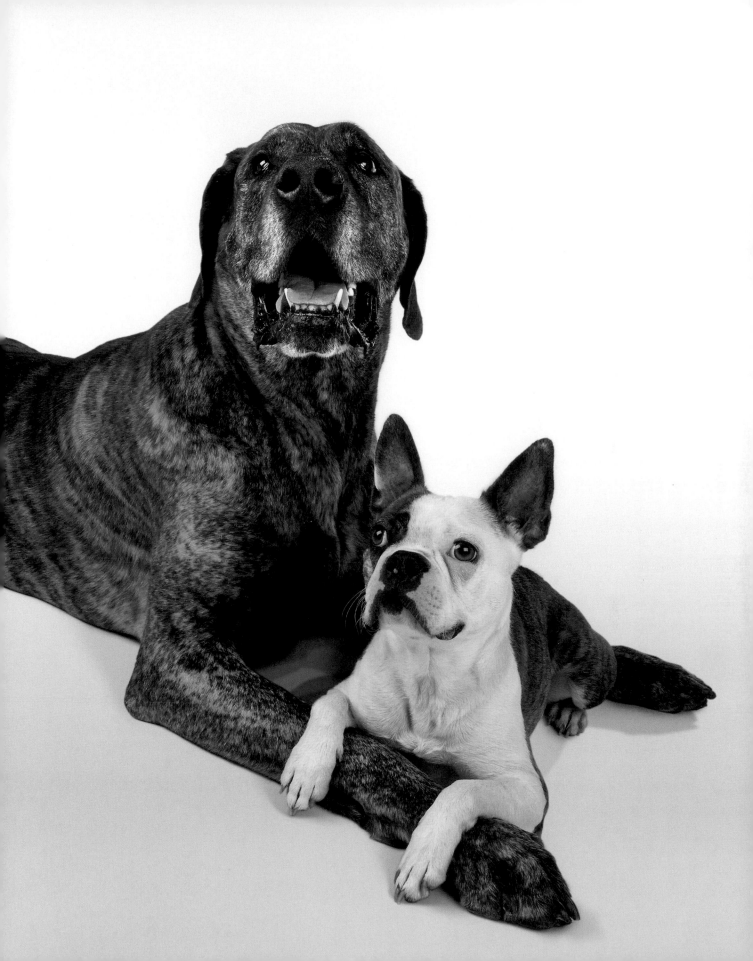

WEIGHT**COMPARISON**

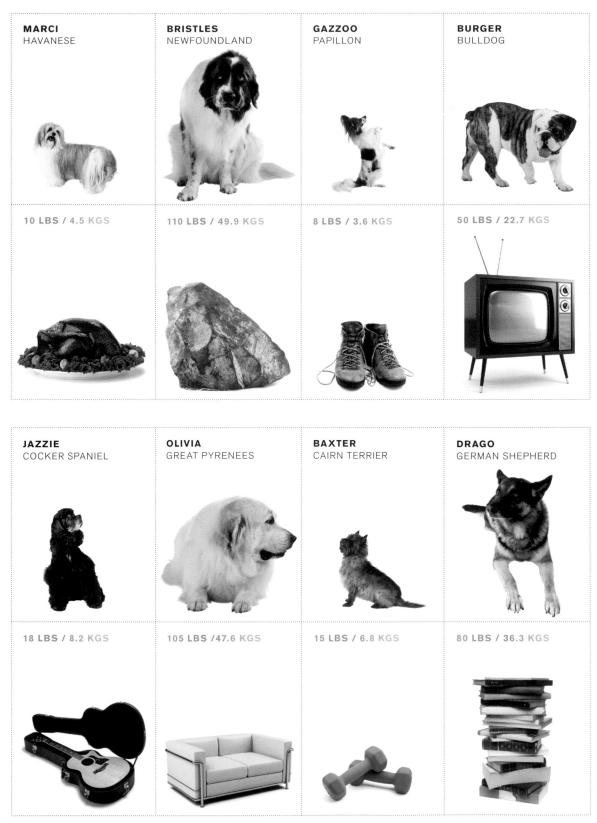

MARCI
HAVANESE

10 LBS / 4.5 KGS

BRISTLES
NEWFOUNDLAND

110 LBS / 49.9 KGS

GAZZOO
PAPILLON

8 LBS / 3.6 KGS

BURGER
BULLDOG

50 LBS / 22.7 KGS

JAZZIE
COCKER SPANIEL

18 LBS / 8.2 KGS

OLIVIA
GREAT PYRENEES

105 LBS / 47.6 KGS

BAXTER
CAIRN TERRIER

15 LBS / 6.8 KGS

DRAGO
GERMAN SHEPHERD

80 LBS / 36.3 KGS

CHLOE
CHIHUAHUA

HEIDI
MIXED BREED

LEXI
RAT TERRIER

RILEY FINN
GERMAN SHORTHAIRED
POINTER

5 LBS / 2.3 KGS

42 LBS / 19.0 KGS

13 LBS / 5.9 KGS

51 LBS / 23.1 KGS

FIFI
GREAT DANE

TINA
TOY POODLE

MURPHY
MIXED BREED

GINGER
ITALIAN GREYHOUND

160 LBS / 72.6 KGS

7 LBS / 3.2 KGS

52 LBS / 23.5 KGS

8 LBS / 3.6 KGS

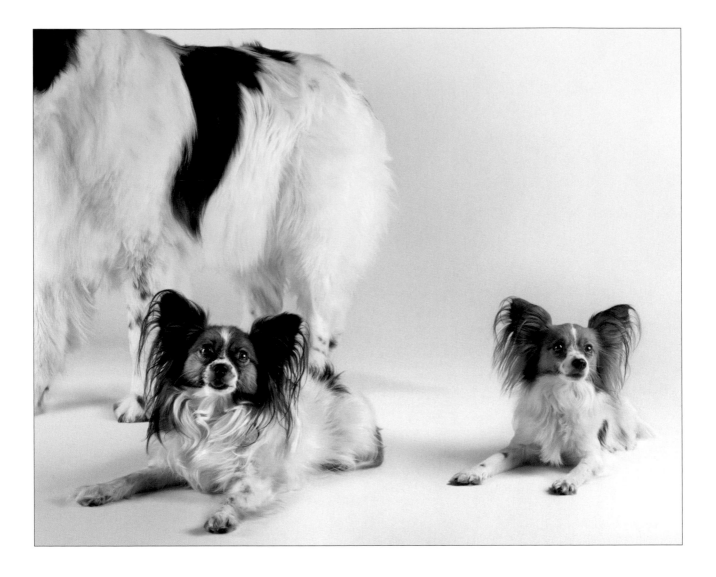

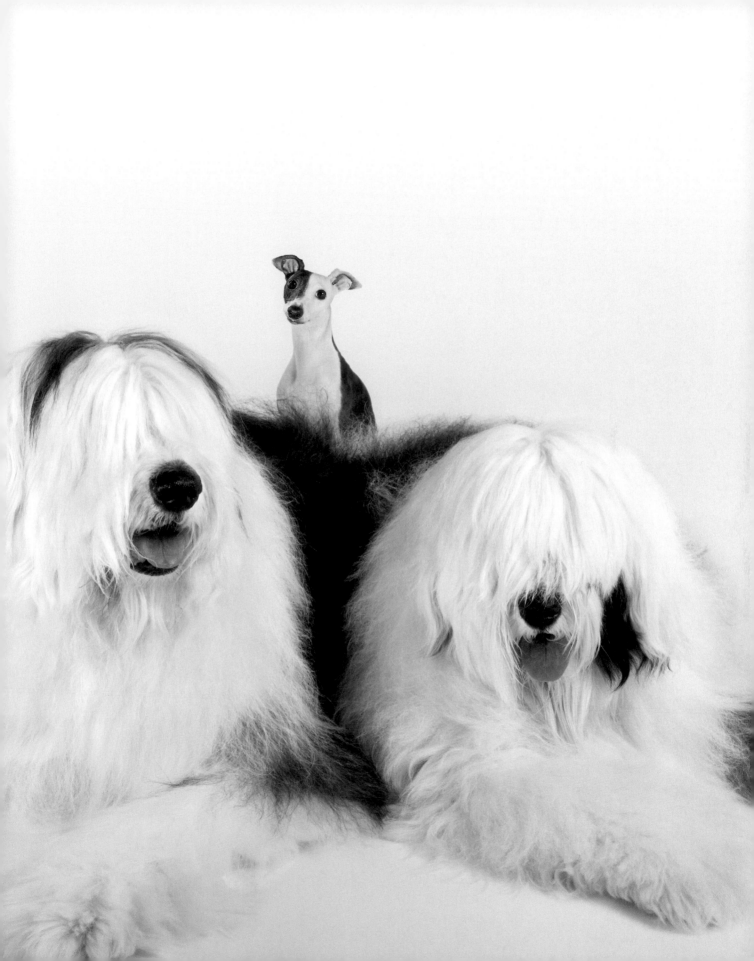

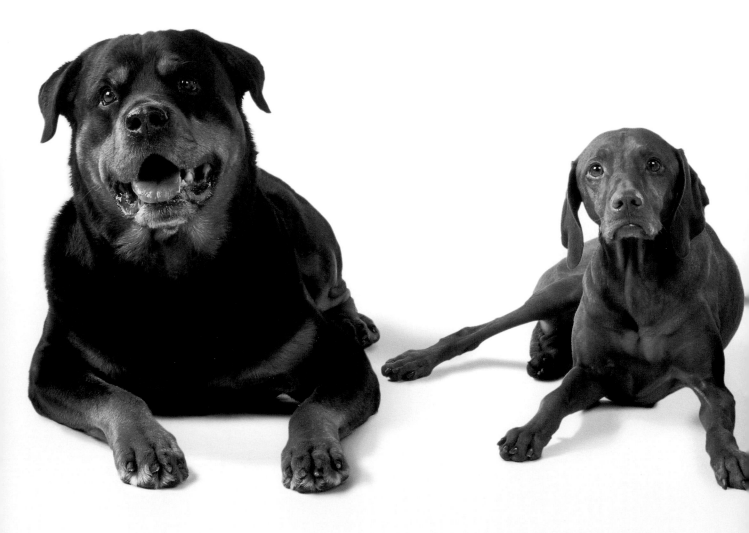

DOGS LEAD A NICE LIFE.
YOU NEVER SEE A DOG WITH A WRISTWATCH.
GEORGE CARLIN

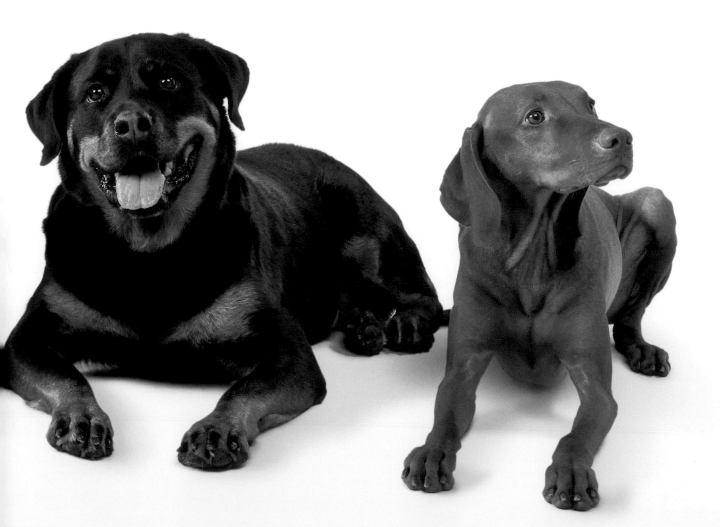

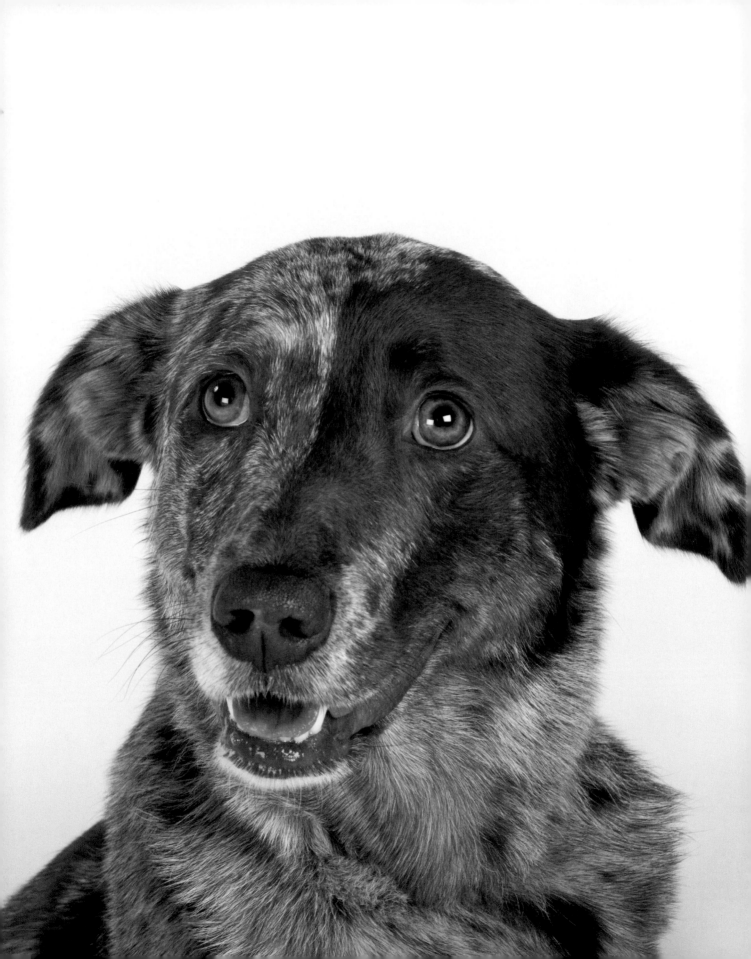

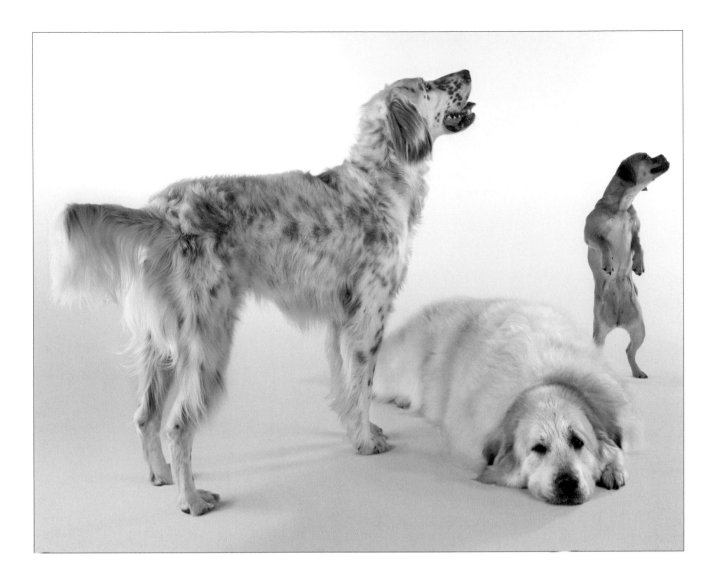

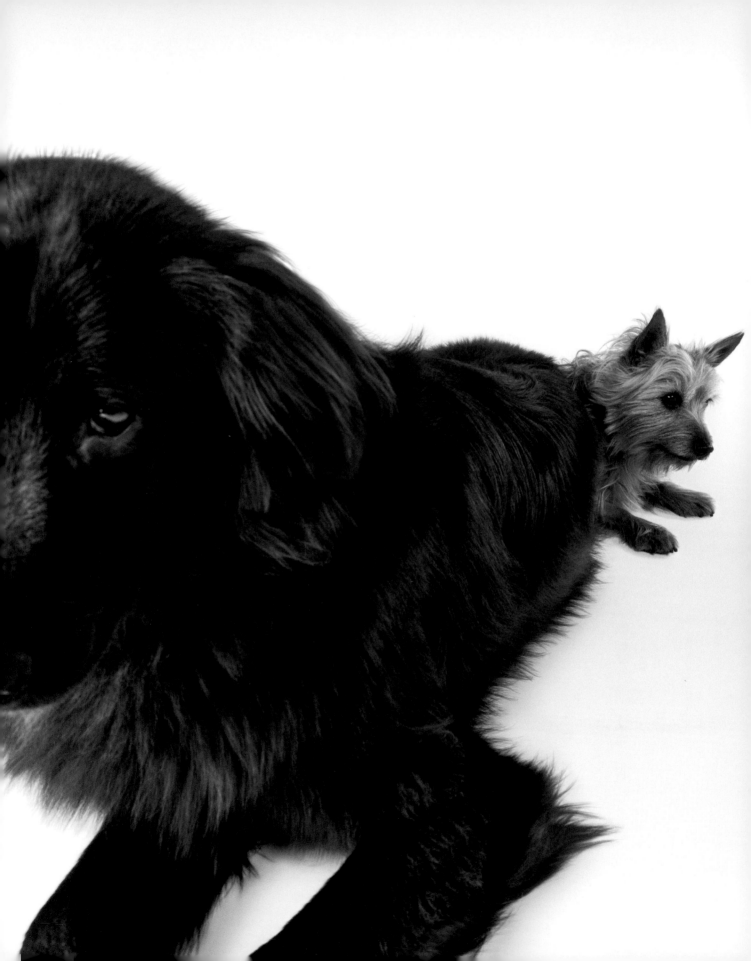

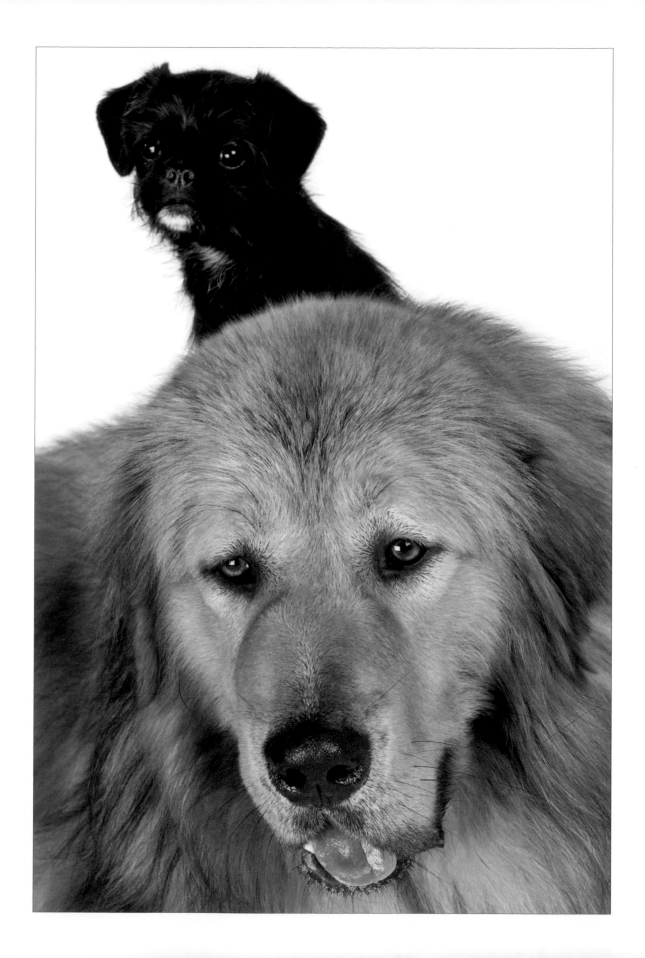

DOGS DON'T MIND

BEING PHOTOGRAPHED IN COMPROMISING SITUATIONS.

ELLIOTT ERWITT

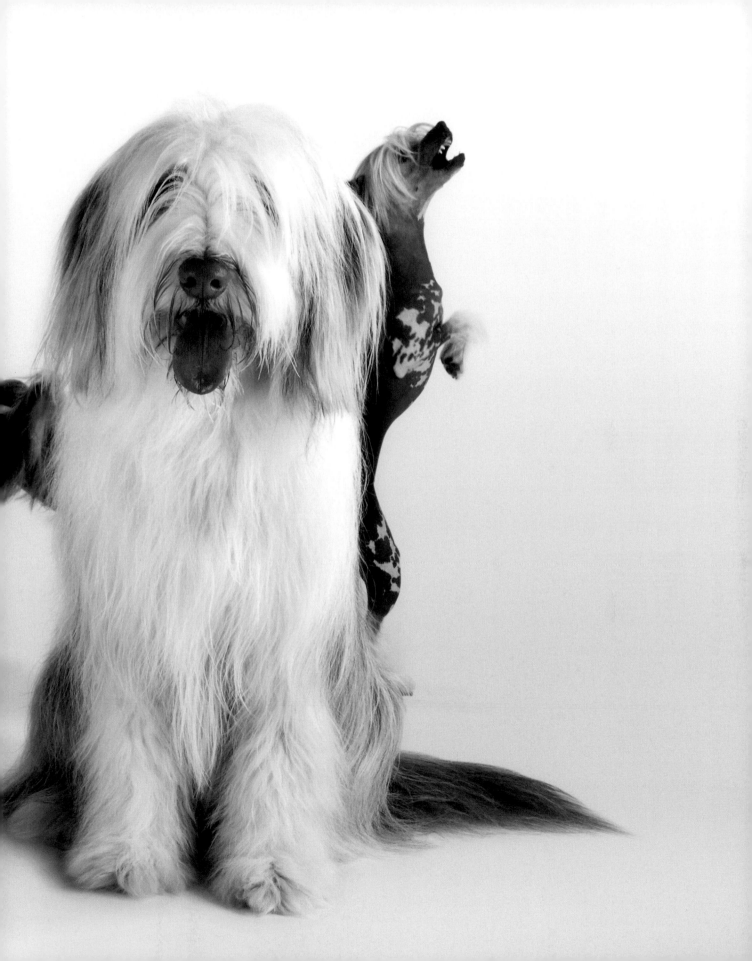

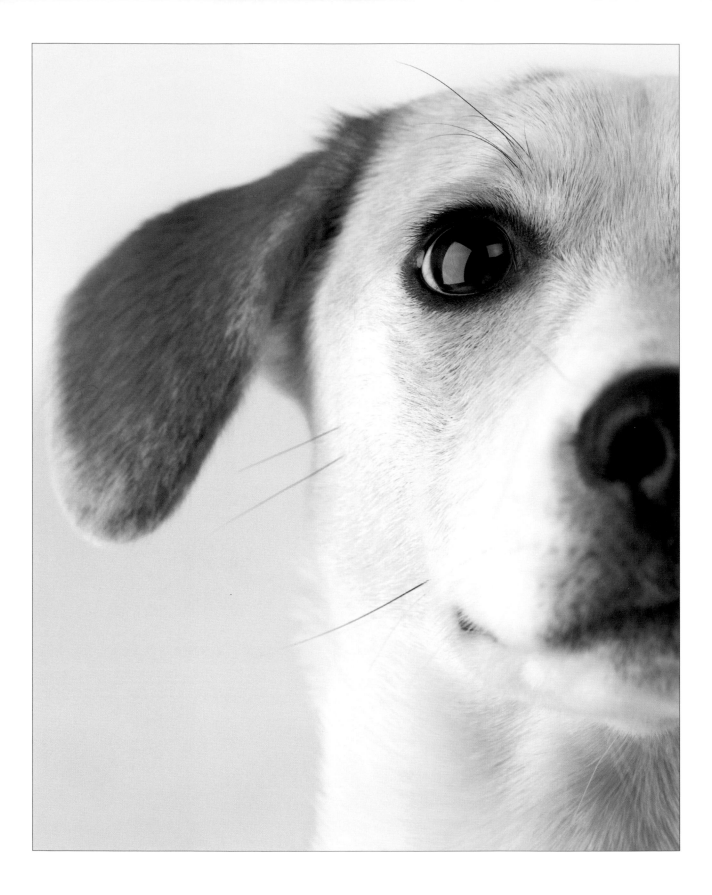

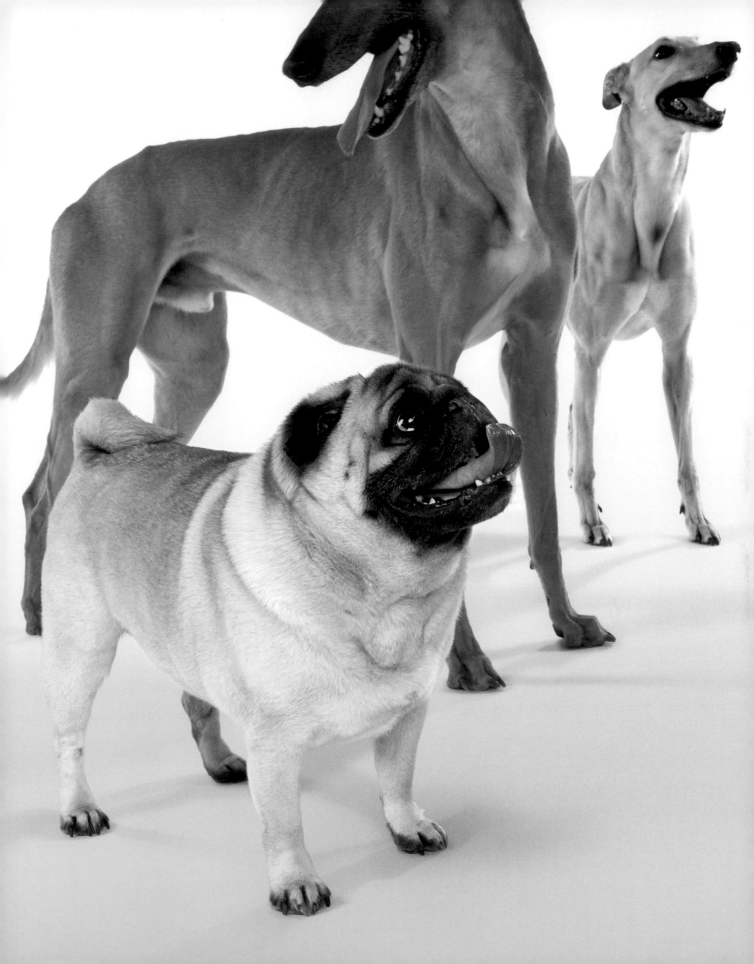

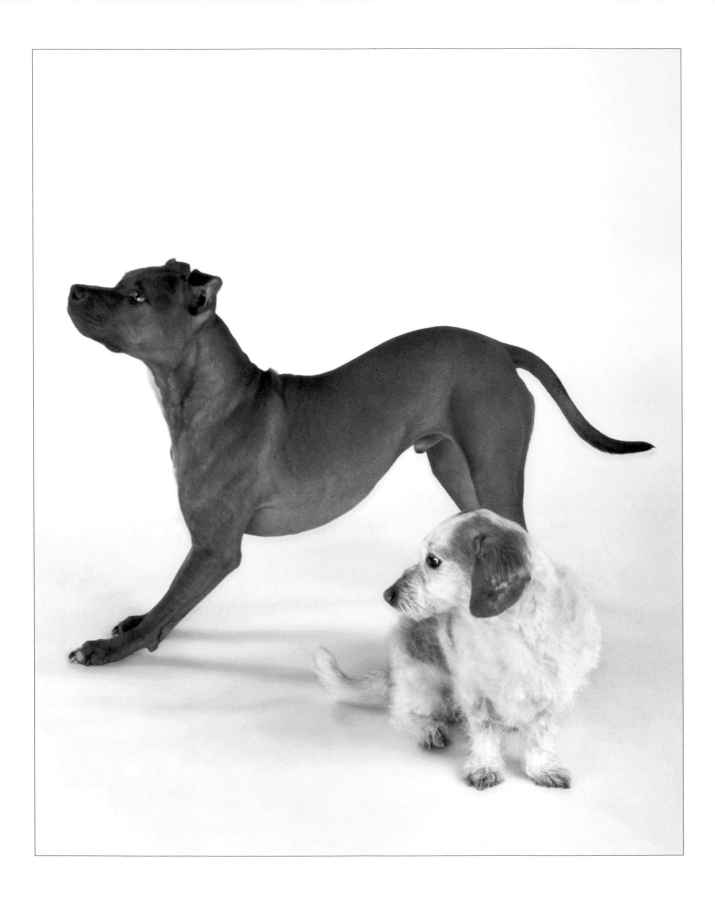

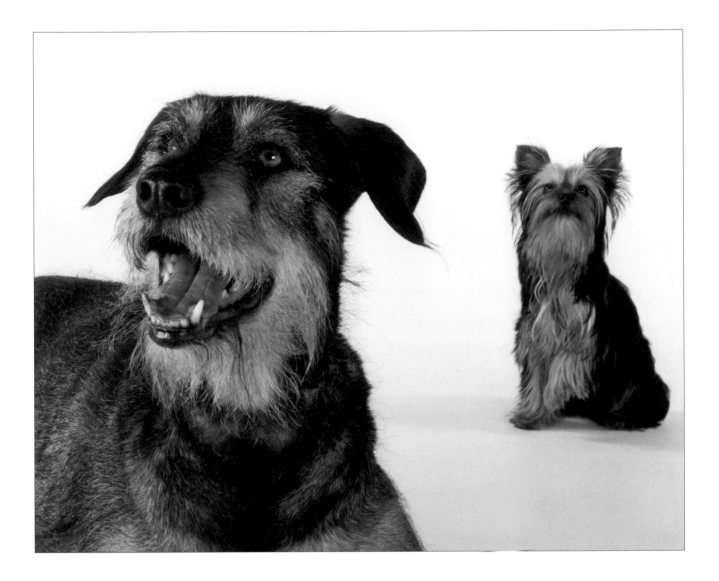

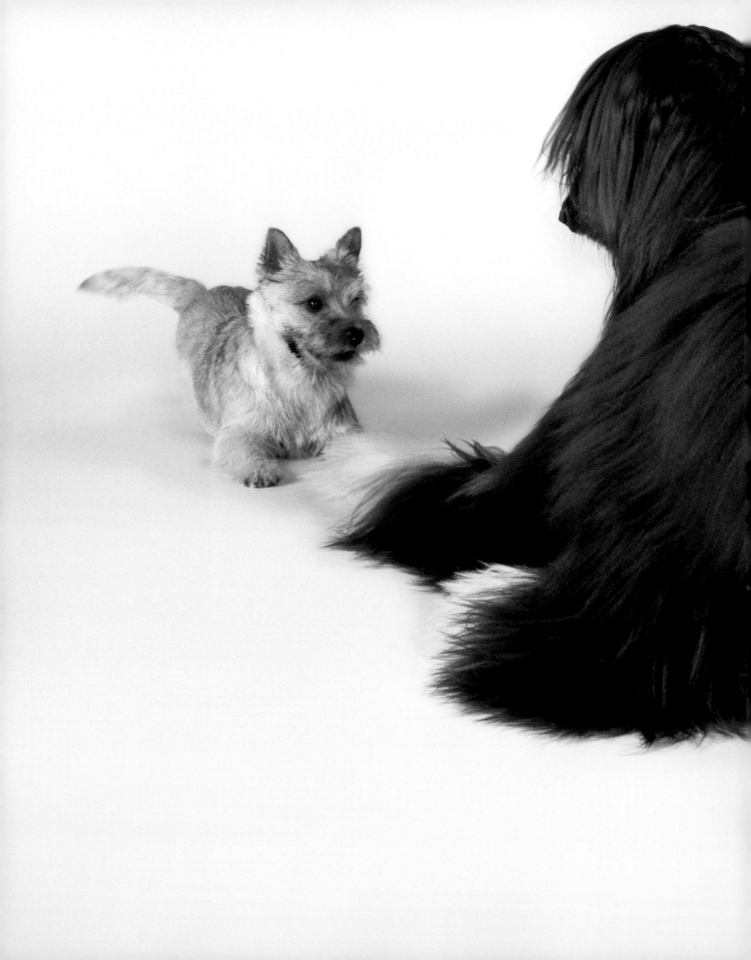

WHEN A DOG WAGS HER TAIL AND BARKS AT THE SAME TIME,
HOW DO YOU KNOW **WHICH END TO BELIEVE?**
ANONYMOUS

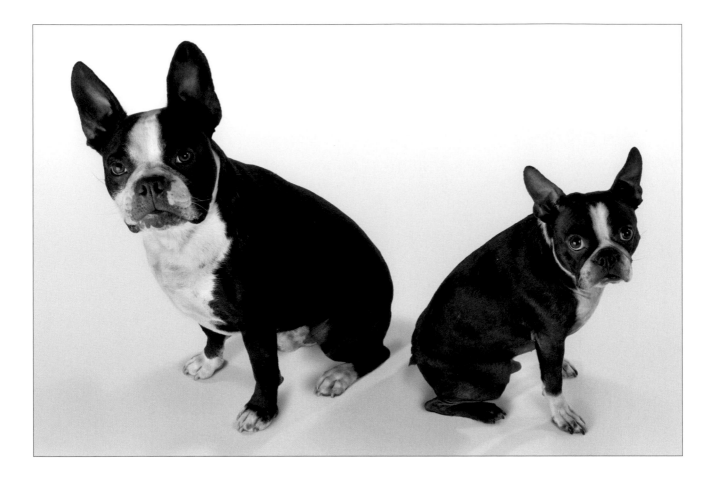

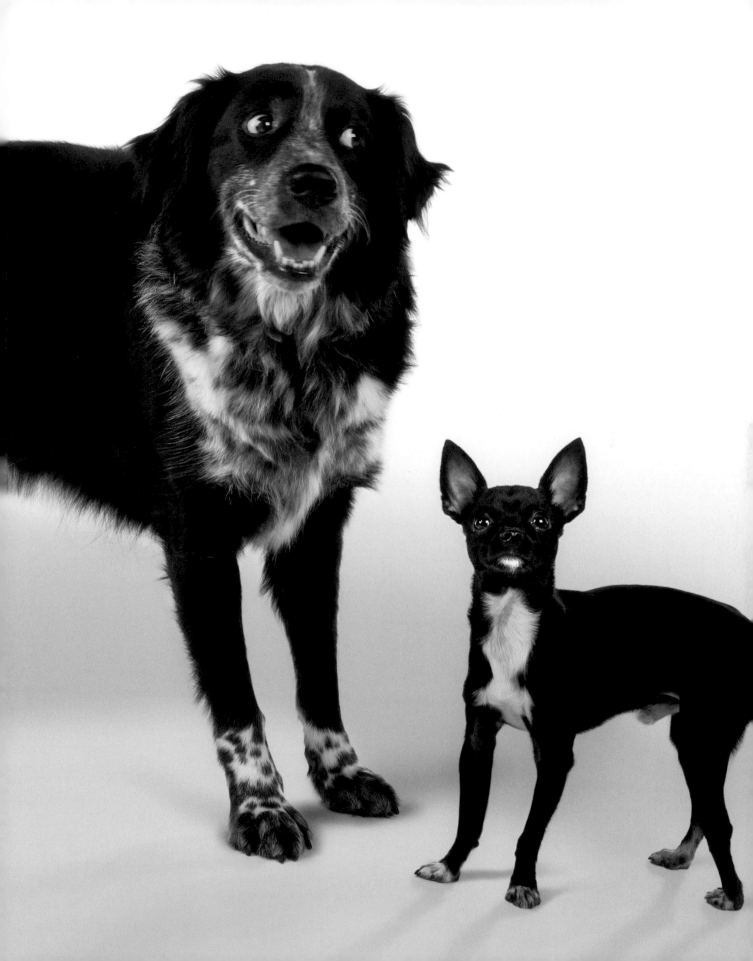

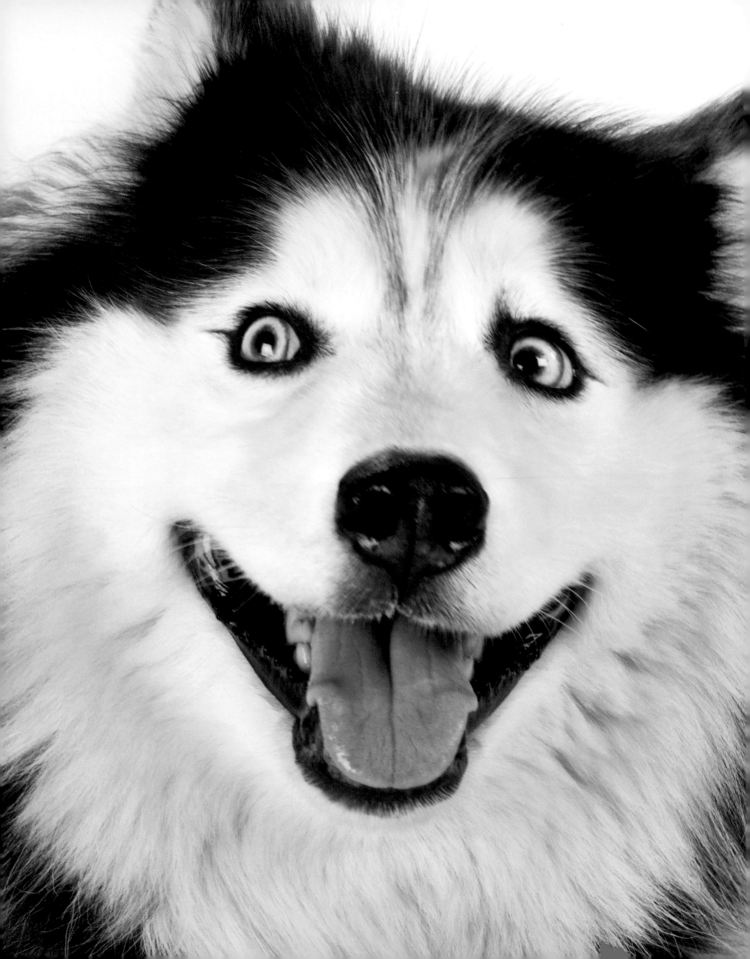

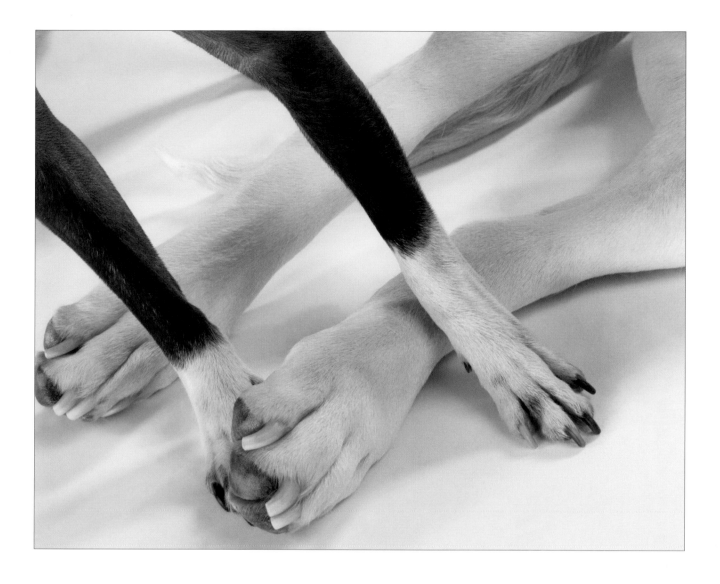

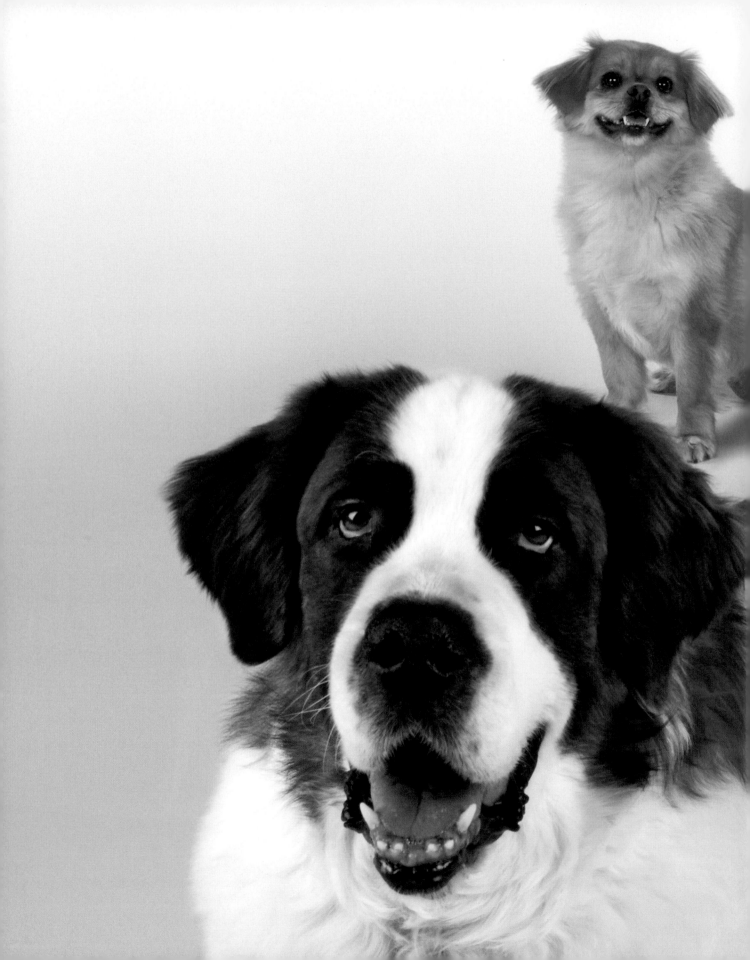

THE GREAT PLEASURE OF A DOG

IS THAT YOU MAY MAKE A FOOL OF YOURSELF WITH HIM AND NOT ONLY WILL HE NOT SCOLD YOU,

BUT HE WILL MAKE A FOOL OF HIMSELF TOO.

SAMUEL BUTLER

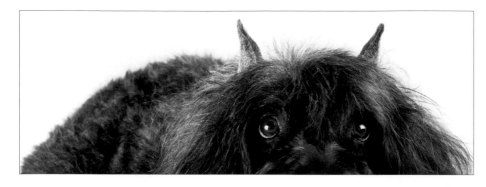

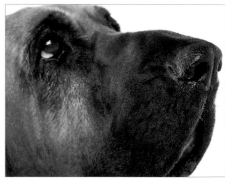
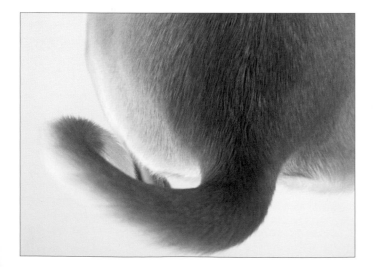
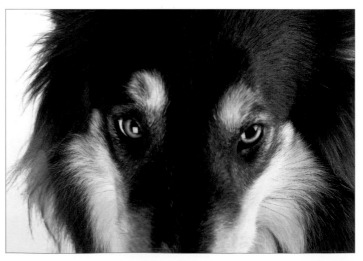

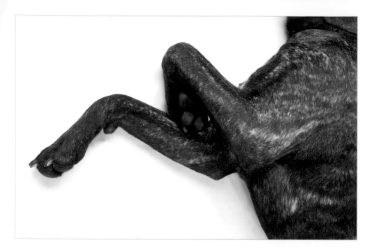
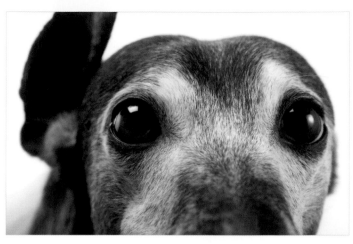
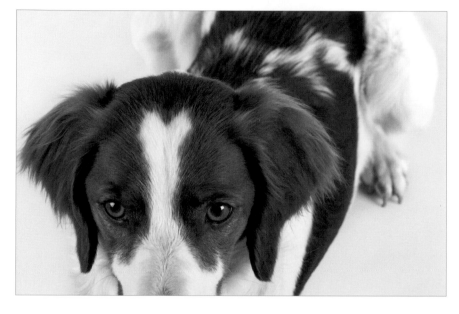
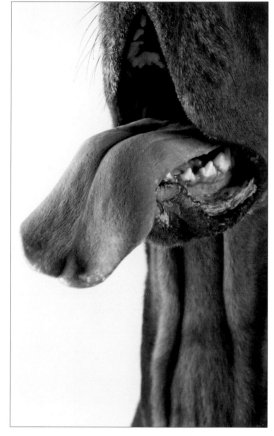
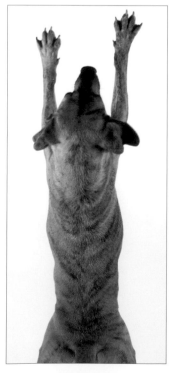
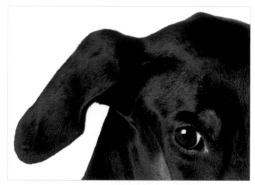
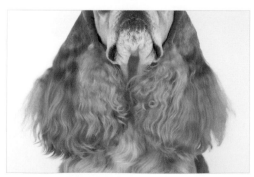
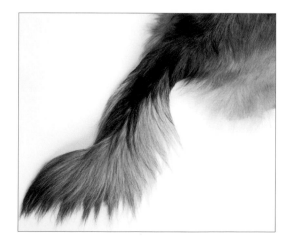

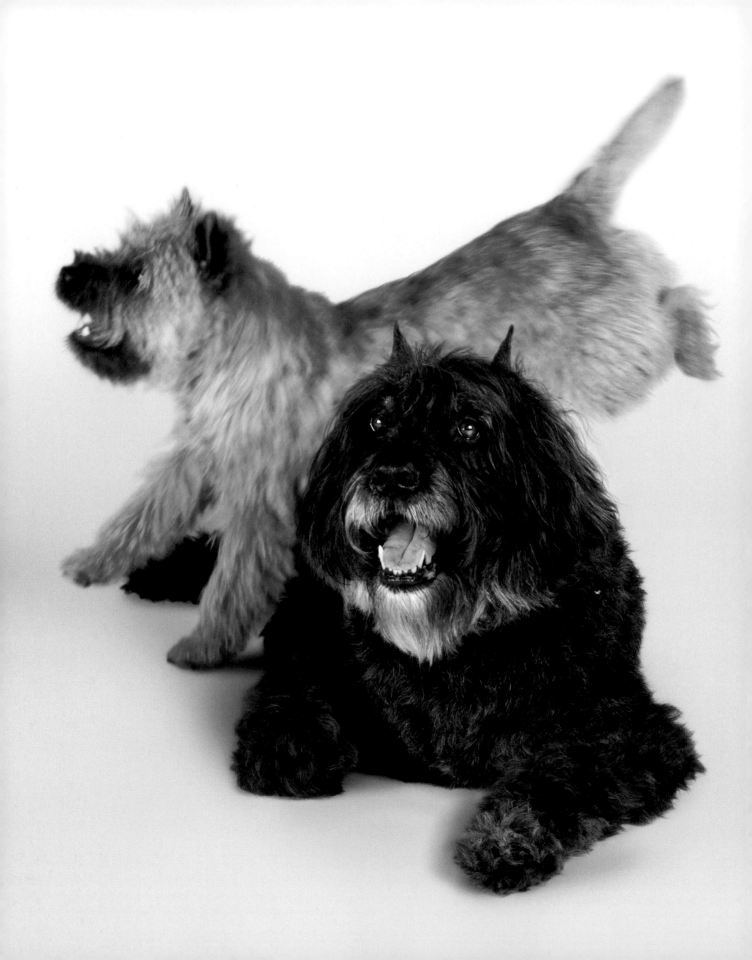

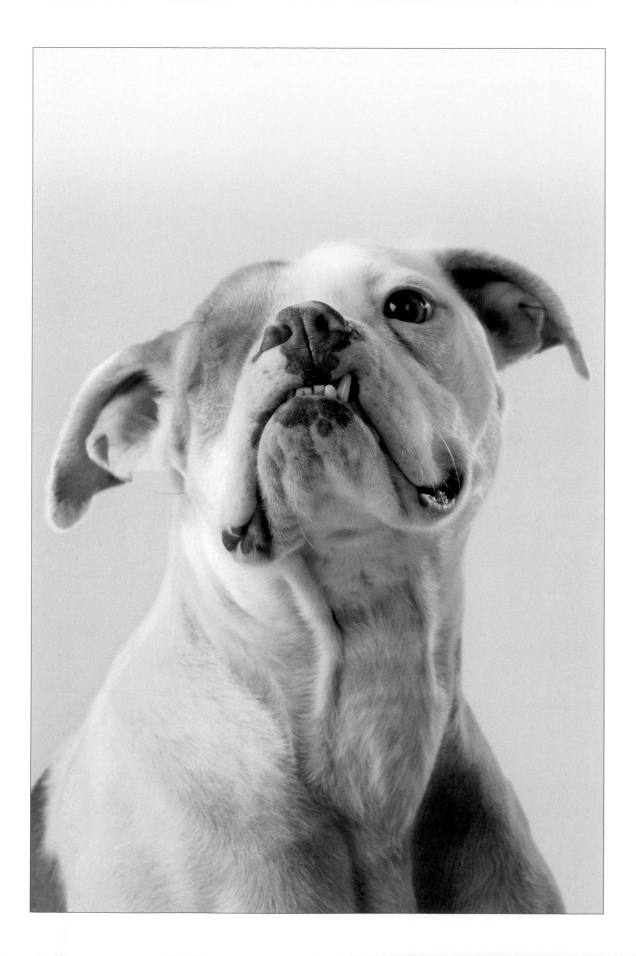

THE BIGGEST DOG HAS BEEN A PUP.

JOAQUIN MILLER

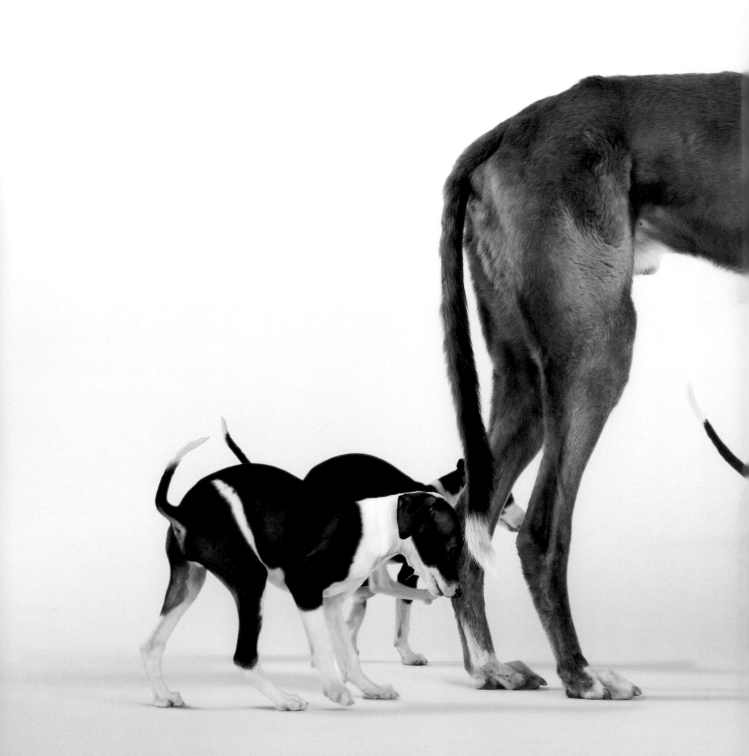

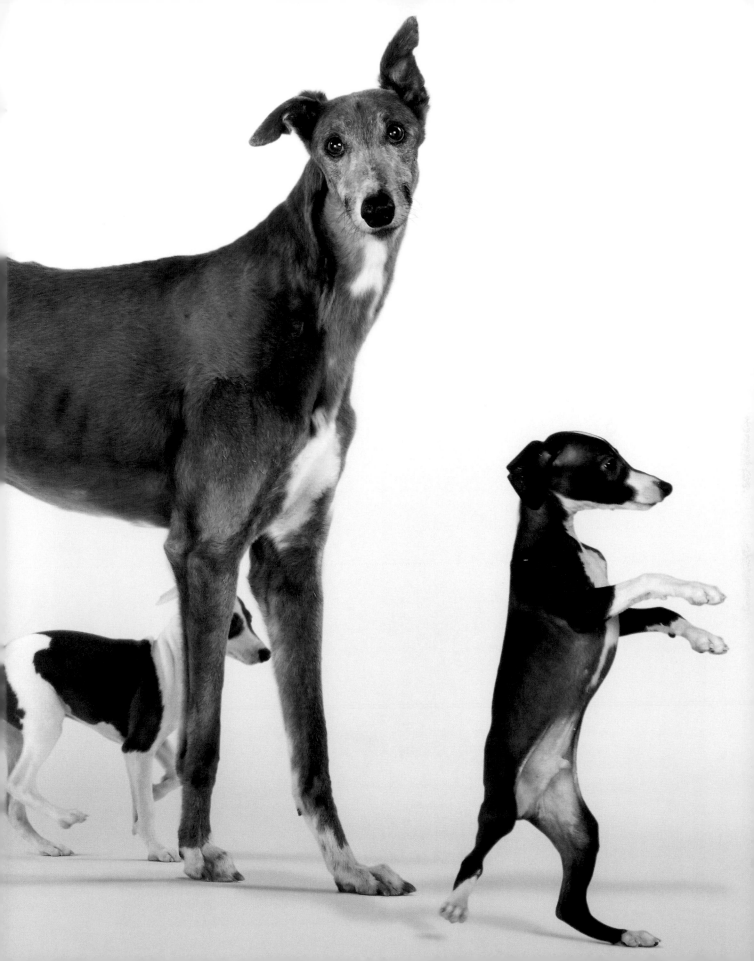

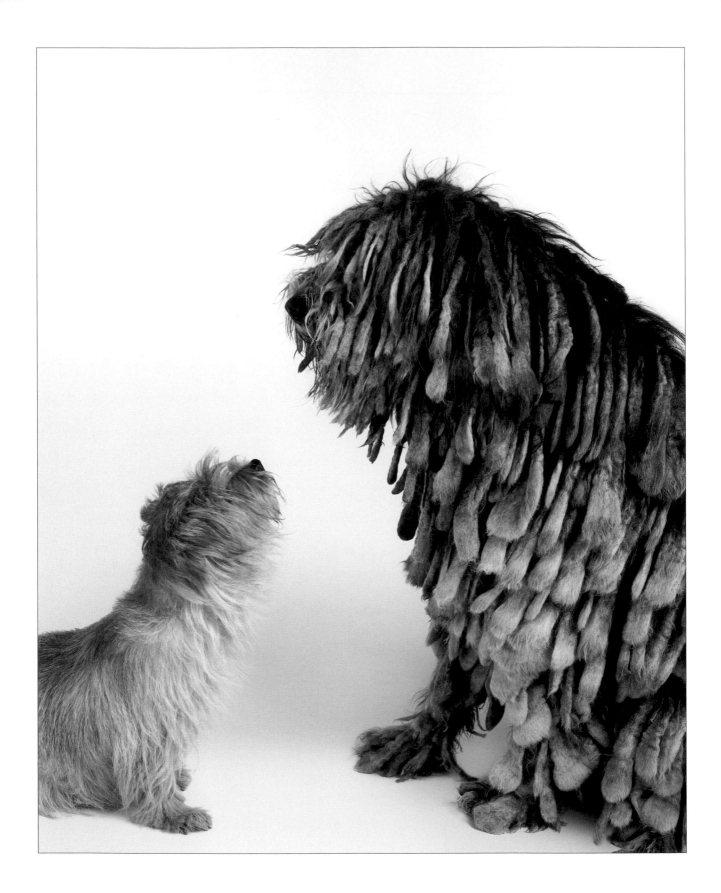

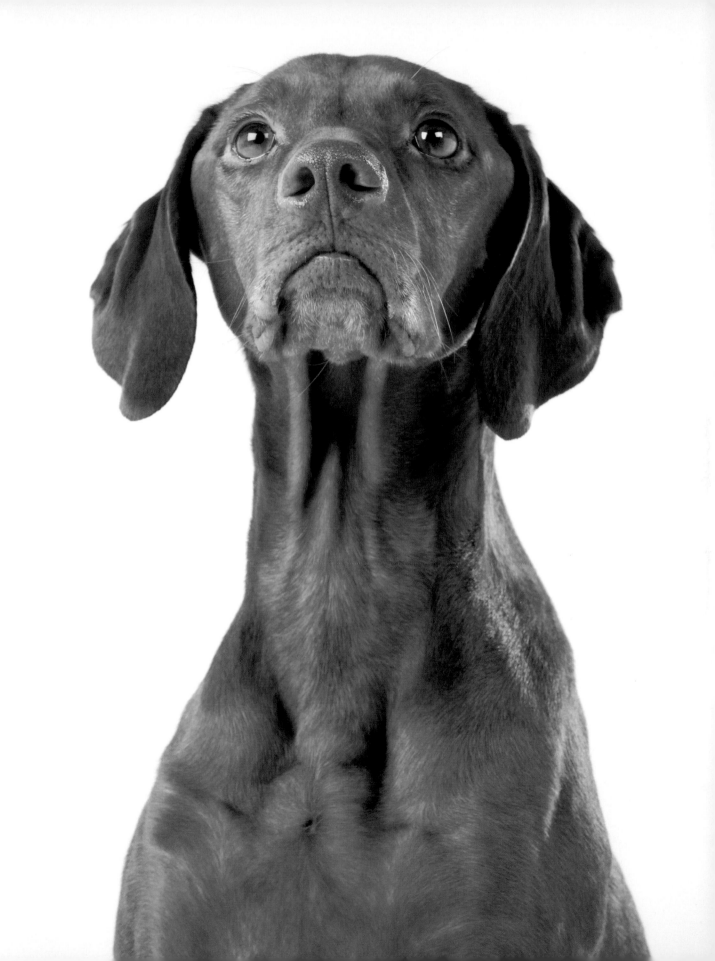

IF SIZE DID MATTER,
THE DINOSAURS WOULD STILL BE ALIVE.

WENDELIN WIEDEKING

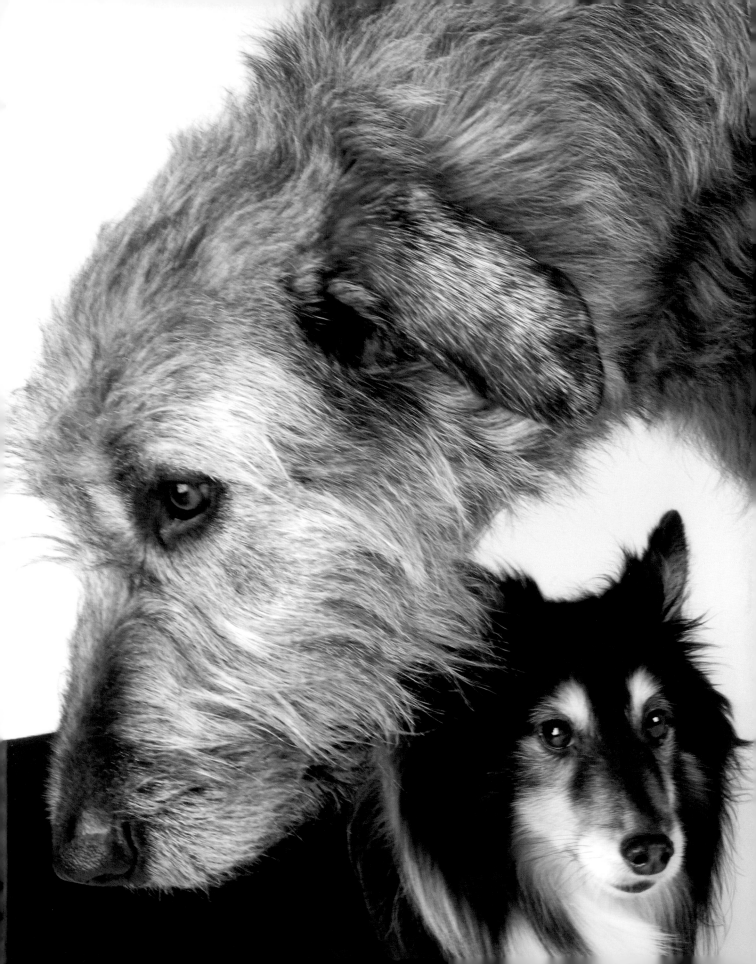

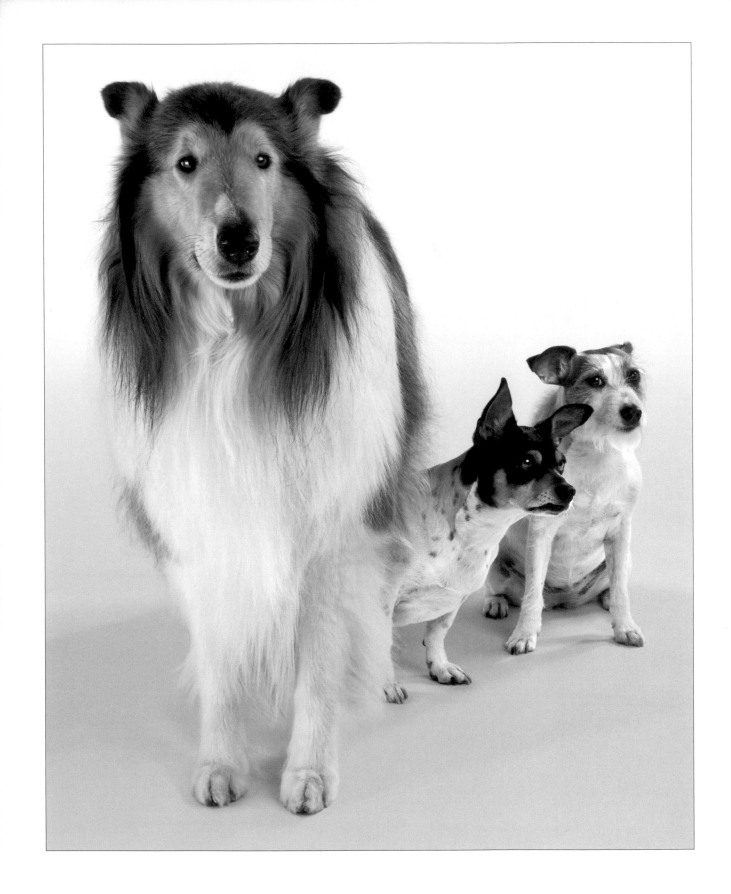

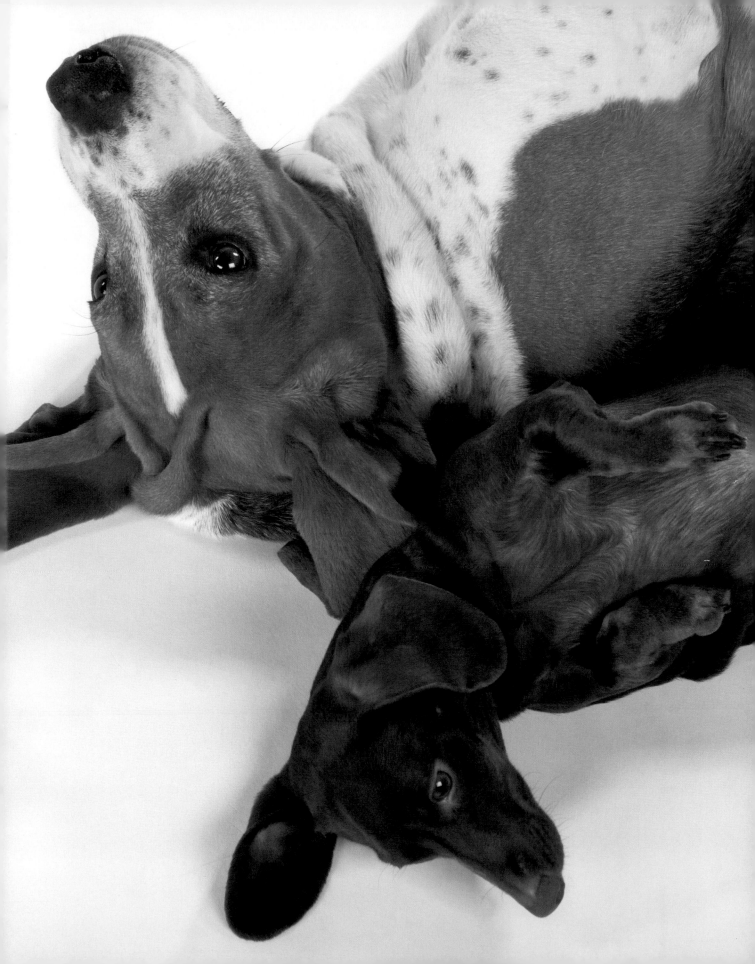

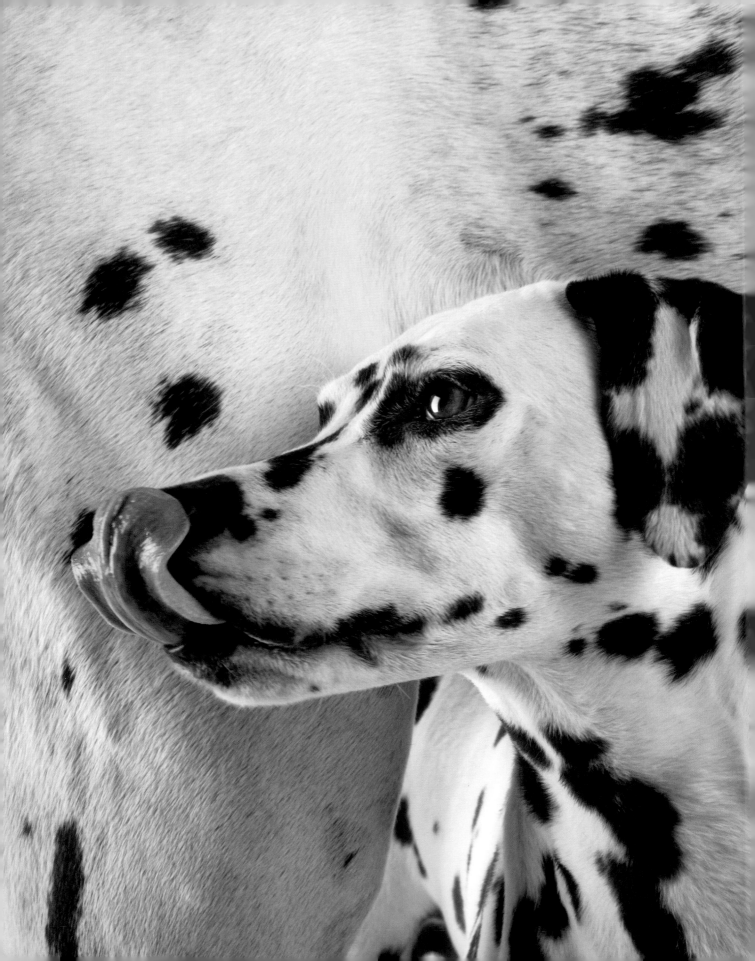

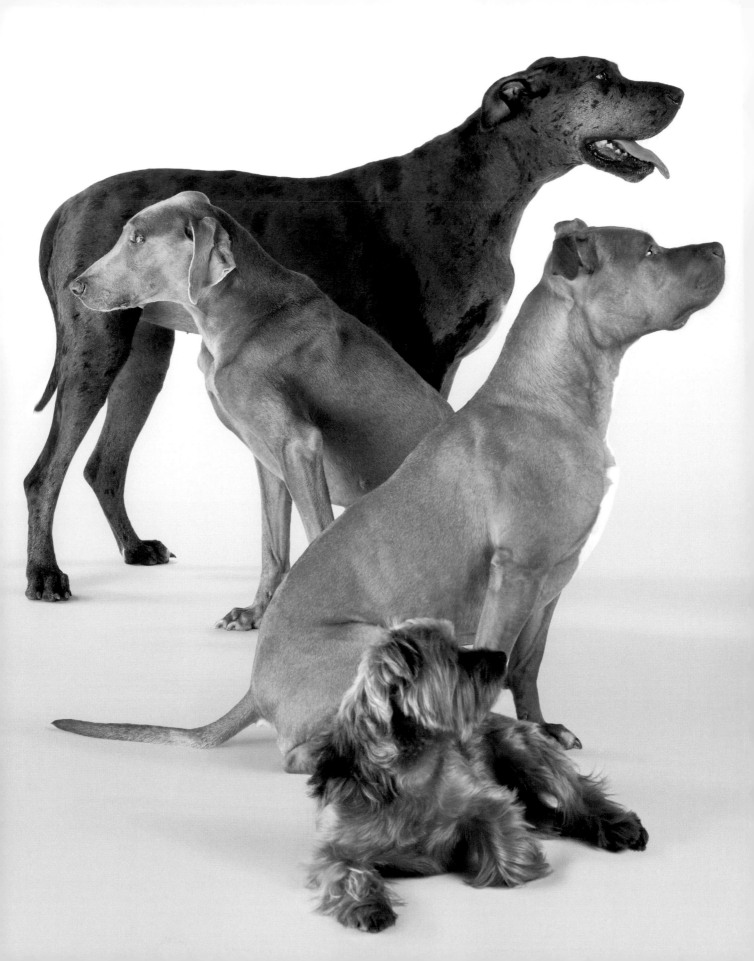

IT ISN'T SIZE THAT COUNTS SO MUCH AS THE WAY THINGS ARE ARRANGED.

E.M. FORSTER

THANKS!

BARBARA KARANT

This book would not have been possible without the enthusiasm, generosity, and talent of an extraordinary team. To and for each and every one of you—small and big—I give the following thanks.

For the visionaries of print and production, I wish to extend special thanks to Jen Bergstrom for having the wonderful idea for this book, for her unflagging desire to realize *Small Dog, Big Dog*, and for putting all the right people on the project; Maria Grillo and Katherine Walker of The Grillo Group for their elegant and thoughtful design; Gary Chassman for his supportive and sage counsel; Erin Ostreicher for her superb research; Michael Nagin for his exemplary creative efforts; Cara Bedick for her guidance and being my go-to girl; Dan Cabrera for picking up where others left off; and, with great admiration, Alexandra Horowitz for her perceptive and eloquent introduction.

I would also like to express my gratitude to Lauren Pearson, the best intern that I could have hoped for; Pete Maloy, Michael Kemp, Adam Kuehl, and Paul Morgan for their technical expertise on our many photo shoots; Erik Sagerstrom, Scott Munro, and Angela Goodman, whose collective keen eye for detail contributed immensely to the final look we achieved; and Kathi Berman, Joy Kalligeros, Catalina Salley, Laura Prohov, Jay Karant, Laura Dion-Jones Casey, Emily Inman, Paul Florian, Jane Allen, and Nancy Bush for support and advice.

Small Dog, Big Dog could not have succeeded without the cooperation of a myriad of dog guardians who brought their animal companions to me, often paired with a friend of contrasting size. We photographed more than 190 dogs—60 breeds and innumerable mixed breeds—during the months we worked on the project. The love you give your dogs—whether rescued from shelters, sired by champions, or adopted from breed rescue—is as remarkable as the dogs themselves. If it is true that animal lovers are the best people, dog lovers are the best of the best.

I would also like to thank all the boarding facilities, vets, and trainers who hosted and assisted with my photo shoots and spread the word to their clients about *Small Dog, Big Dog*. Special thanks to Jamie Damato, Ruby Madrigal, Joan Harris, Margaret Fulghum, Brenda Lang, Bev Petrunich, Kellee Joost, and Bruce Blaine. I learned a lot from you and your clients and am a much more savvy "dog person" than I was before embarking on this project. Your support for me and your concern for the dogs are inspiring.

A heartfelt thank-you from the Morris Animal Foundation and myself goes to the following individuals and organizations for their steadfast support and dedication to the Canine Cancer Campaign, an unprecedented initiative to cure canine cancer: Greg and Lin Battaglia and Motivational Dog Training—Agility Ability LLC of Sparks, Nevada; Sandy Vilahu of Elk Grove, California; and Wag'n Enterprises of Herndon, Virginia.

Finally, I wish to extend the biggest thank-you of all to Keturah Davis, without whose calm, focused guidance, technical prowess, critical aesthetic, and sound judgment I could never have completed this book. Her contribution to the creation of *Small Dog, Big Dog* has been invaluable.